FARNHAM AT WORK

PEOPLE AND INDUSTRIES THROUGH THE YEARS

FIONA TAYLOR

AMBERLEY

Farnham at Work is in loving memory of my father Kevin Taylor and my sister Colleen. Both were Farnham people.

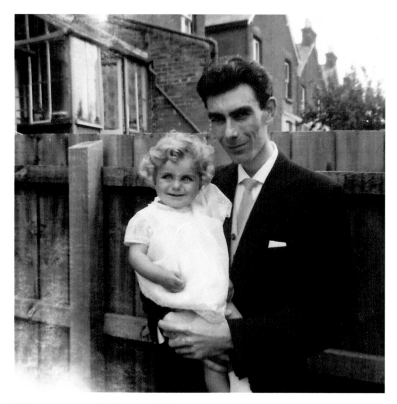

Babe in arms – Colleen and Kevin.

First published 2024

Amberley Publishing
The Hill, Stroud
Gloucestershire, GL5 4EP

www.amberley-books.com

Copyright © Fiona Taylor, 2024

The right of Fiona Taylor to be identified as the Author
of this work has been asserted in accordance with the
Copyrights, Designs and Patents Act 1988.

ISBN 978 1 3981 1355 8 (print)
ISBN 978 1 3981 1356 5 (ebook)

British Library Cataloguing in Publication Data.
A catalogue record for this book is available
from the British Library.

Typesetting by SJmagic DESIGN SERVICES, India.
Printed in the UK.

CONTENTS

INTRODUCTION

I'm always proud to call Farnham my hometown. It's a beautiful Surrey market town nestled in a river valley with the River Wey flowing through the centre. It has an abundance of character with Georgian houses, cobbled streets and hanging baskets. Farnham is surrounded by countryside and villages, all with their own unique appeal and charm. Fewer than 4,000 people actually live in Farnham town centre, with 34,000 residents living in the villages that make up Farnham.

During the Palaeolithic Age Farnham was little more than a dirt track. A criss-cross of tracks started to sprout during the Bronze and Iron Ages, and amid Roman occupation small potteries were developed. It was not until the Saxons in AD 688 that Farnham was given its name 'Fearnhamme', referring to the fern and bracken which is still evident today, and the water meadows which make up large areas of Farnham. From Saxon time onwards the town expanded.

By the time of the Domesday Book in 1086 the Bishops of Winchester were described as having 'always held' Farnham and the town was the centre of what had become one of the wealthiest of the numerous Winchester estates with assets including forty hides, one church, six watermills and forty-three ploughs.

Farnham was given its name because of the ferns growing. Today you can still see them in the hedgerows.

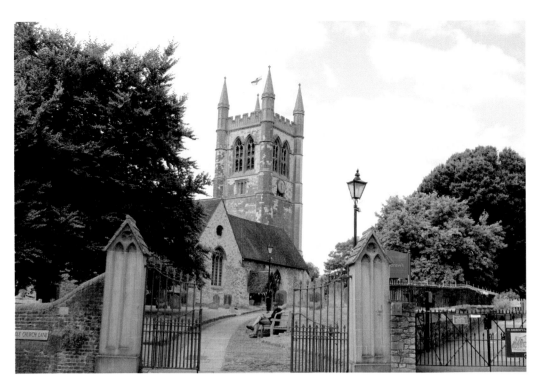

St Andrew's Church. Parts of it date back to the Middle Ages, and now, like then, it dominates the Farnham skyline.

In 1138, Henry de Blois (grandson of William the Conqueror) started building Farnham Castle to provide accommodation for the Bishop of Winchester who frequently travelled between Winchester and London. Farnham's convenient location naturally led to trade and by 1216 it hosted a weekly market and annual fair, which soon became one of the largest in the area. In around 1207 Farnham was formally planned with Castle Street and The Borough becoming the town centre which shifted the core settlement of Farnham from around the church to the castle. Farnham was awarded its town charter in 1249. A palace and deer-park were added to the castle in the thirteenth century. Over the years it has had many royal visitors including King John, Henry VIII and Queen Elizabeth I. Today the castle still dominates the town, and its park and grounds is enjoyed by many Farnham residents.

During the Medieval and Tudor periods Farnham's strategic position on a main route ensured that its prosperity was consolidated. This was due largely to the wool and wheat trade. This prosperity was shown by the building of a Market House at the bottom of Castle Street in the 1560s where bailiffs and burgesses could meet and from which business could be done. This attractive building was later demolished by the Victorians.

The wool market declined in the sixteenth and seventeenth centuries and its place was taken by hops. Hops had been grown since the latter half of the sixteenth century, but it was not until the mid-1700s that they became the linchpin of Farnham's prosperity.

As profits rose for the hop owners the old Tudor timber-framed buildings of Farnham were swept away and new splendid Georgian town houses were built in their place.

The arrival of the railway in 1849 resulted in a wider range of mass-produced goods becoming available to local people.

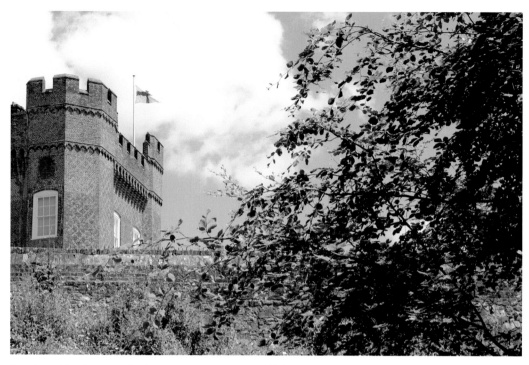

Farnham Castle, overshadowing Farnham since 1138.

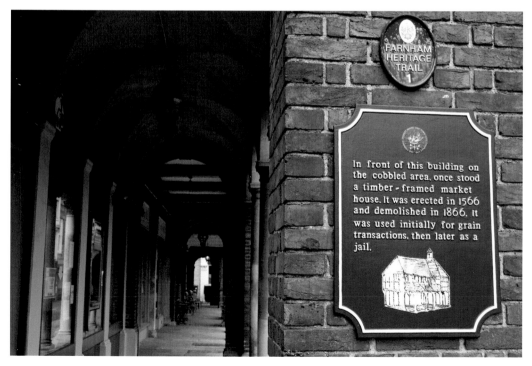

Plaque showing where the timber-framed Market House once stood. It was constructed in 1566 and demolished in 1866.

In 1854 the army arrived near to Aldershot village. With little infrastructure in place Farnham tradesmen were well placed to provide much in the way of goods and services to the army camp. Troops visited Farnham to shop, sup a pint or to catch a train.

Various industries supplemented incomes, such as agricultural labouring and gravel pit quarrying. The Victorian and Edwardian eras saw a change of the makeup of Farnham town centre when market stalls started to become shops. Around the same time Farnham Art School was founded and has played a major part in Farnham's development as a Craft Town.

The invention of the motor car had a profound an impact on the world as it changed the way people lived and influenced business – Farnham has its own story to tell about its part in the development of the motor vehicle.

Farnham at Work is discussing these past industries and events, and how they have added layers to Farnham's character. By doing this it allows us to imagine the lives led by men, women and children who once lived and worked in Farnham.

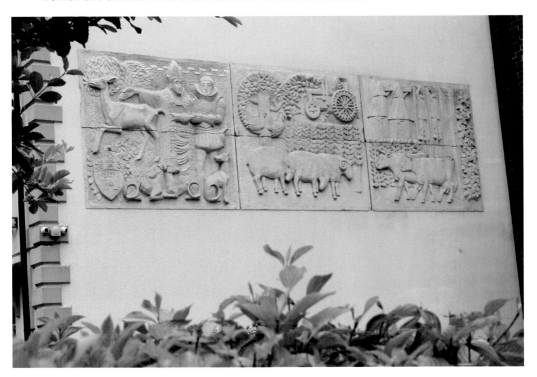

Carved stone panels depicting Farnham history, designed in 1961. In Longbridge, Hawthorn Lodge.

WOOL TRADE

In medieval Farnham, wool was big business. There was enormous demand for woollen products made from cloth, and many people who had land, from peasants to gentry, farmed sheep. One of Farnham's major producers of wool were the Cistercian monks of Waverley Abbey.

Waverley Abbey was founded in 1128 on the flood plains of the River Wey by William Giffard, Bishop of Winchester, who donated 60 acres of arable land and pasture to a reforming Cistercian religious order consisting of twelve monks and their Abbott who arrived from L'Aumone in France. It was the first Cistercian house in Britain.

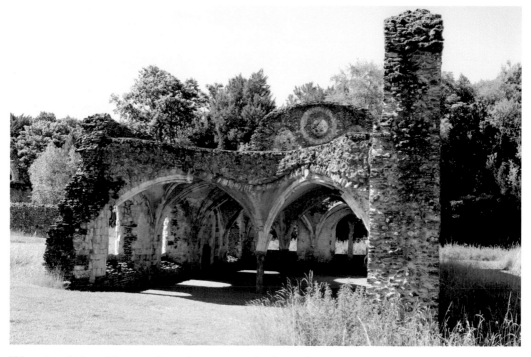

Waverley Abbey. The monks only wore undyed woollen habits and therefore became known as the White Monks.

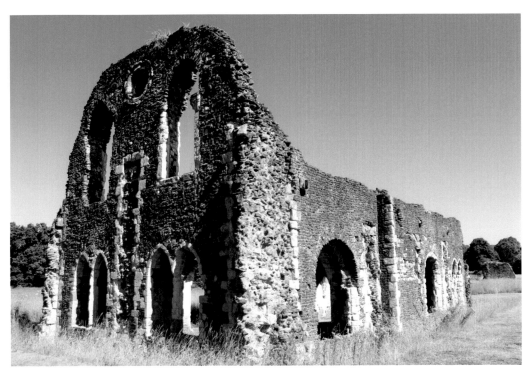

Waverley Abbey. All that is left today is atmospheric ruins home to an abundance of wildlife.

The monks' lives were characterised by simplicity and austerity and they took vows of poverty, obedience, work, prayer and silence. The monks were given just two habits, one blanket and some woollen stockings. They followed a meagre vegetarian diet. The original emphasis was on seclusion, prayer, manual labour and self-sufficiency. The Abbey population grew and by 1187 had over seventy monks and 160 lay brothers, 571 acres of land with a functional mill, and four bridges. They had thousands of sheep who pastured the area around Farnham in Tilford and Elstead.

In medieval Farnham preparing the wool for cloth was a cottage industry. This usually involved the children carding, the mother spinning and the father weaving. The Domestic System was popular because it allowed the whole family to work together and they could control when and how fast they worked. The wool would be delivered to the worker's home and the carder used a pair of cards (handheld boards) that had wire studs. The wool would be placed between the cards and pulled repeatedly to open up the fibres so that they would be ready for spinning into yarn. The spinning was normally done by the women and young girls of the household. If these girls had not married at a young age, it was believed that they would remain unmarried all their life – hence the term spinster today. The yarn would then be woven by a skilled weaver using a handloom.

The cloth was then passed to clothiers, who would pay millers to have the cloth fulled by washing it in a solution to loosen the grease from the wool. In the early days the solution was urine collected by the cask from the cottagers, who were paid a penny a bucket. The surname Fuller originates from possibly one of the worst jobs in history – i.e., the wool was placed in a barrel of stale urine and the fuller spent all day trampling on the wool to produce softer cloth.

The thirteenth-century Tilford West Bridge. This preserved packhorse bridge was built in around AD 1286. The ford it crosses was built by the Waverley Abbey monks in 1128.

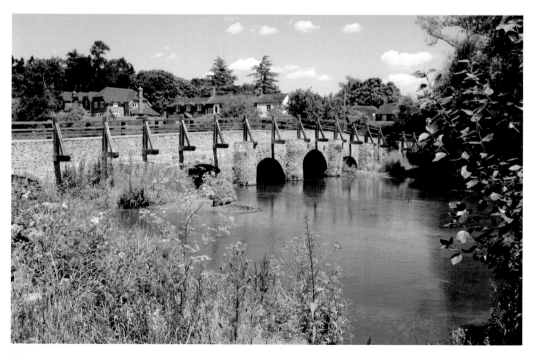

Tilford's new bridge. This bridge replaced the 1941 bridge built by the Army.

Tilford's Oak, also known as Kings Oak or Novel Oak, is believed to be at least 800 years old.

Watermills started to be used for fulling in around 1185. A solution of Fuller's Earth was used, which was a natural resource found in Surrey and was first used by the Romans. It was mined from bell pits to be sold on to the woollen mills. Such was its commercial importance laws preventing its export had been introduced in the 1690s. These laws were not repealed until 1825. The cloth then had a final rinse in clean water. The mills were a noisy affair and the sound of the force of the water would carry across the fields of Farnham.

After the cloth had been rinsed it was then stretched out to dry on racks studded with tenterhooks – L-shaped nails which securely held the cloth in position. These racks allowed the even drying of the cloth. Once dried, the cloth was brushed with a teasel plant to raise the nap, and then sheared to produce a smooth finish.

In June 1348 the Black Death arrived in England via Melcombe Regis, Dorset, by a sailor from Gascony. How the people of Farnham must have feared and prayed as they heard that the deadly disease was travelling along the coast and inland. They would have received the terrifying news that Winchester had taken a terrible toll of death. The plague arrived in Farnham in October 1348. The Pipe Rolls of the Bishop of Winchester describe that by the following autumn an estimated 740 people had died at Farnham – around 20 per cent of the population. The following year over 400 other residents died. When the plague finally left in 1351 almost 1,400 people had died – between a third and a half of the population. The monks at Waverley Abbey suffered large losses as they had provided shelter for pilgrims who may have unknowingly brought the plague with them. The emotional impact and the impact on productivity in Farnham would have been huge. Many of the farms became derelict and there was a slash in the cost of livestock and inflation in the cost of labour.

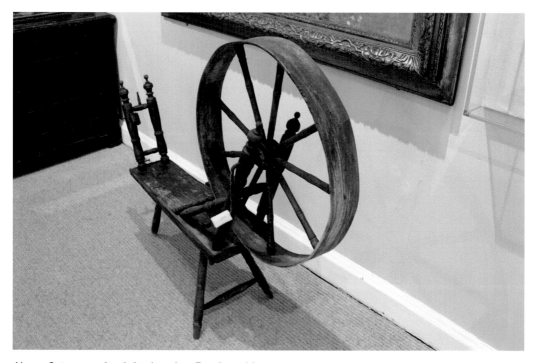

Above: Spinning wheel displayed at Farnham Museum.

Below: Bourne Mill, a seventeenth-century mill. It was gutted by fire in 2015 but has been restored and is now an antiques centre.

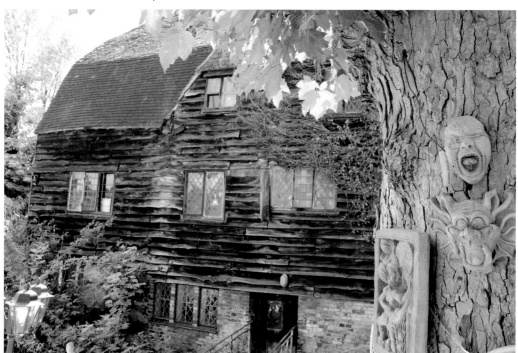

Above: The Hatches, Wrecclesham. Weydon Mill once would have joined The Hatches and was a fulling mill leased to Waverley Abbey.

Below: Hatch Mill, 1904, Frith Series. There was once forty mills along the River Wey. Hatch Mill has been a watermill, laundry, rehearsal room and is currently a care home.

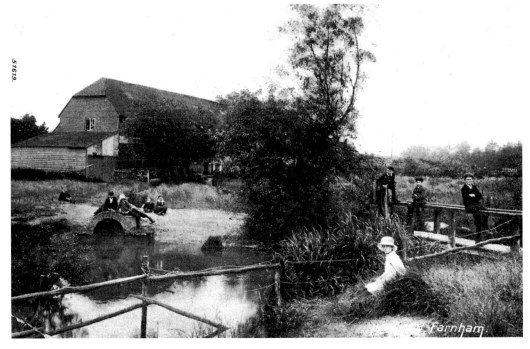

Teasel plants were set into a frame and then piled across the cloth to raise the nap. The Romans used to use the skin of a hedgehog!

After the plague the wool industry picked up again and was the backbone and driving force of Farnham's economy until the late fifteenth century. At this time the wool trade in England was described as 'the jewel in the realm'. To this day the seat of the Lord High Chancellor in the House of Lords is a large square bag of wool called the 'woolsack', a reminder of the important source of wealth in the Middle Ages. A law was passed that all Englishmen except nobles had to wear a woollen cap to church on Sundays, part of a government plan to support the wool industry.

The wool trade throughout England declined in the sixteenth and seventeenth centuries. This was partly due to the decline in the quality of English wools, perhaps somewhat due to a switch in focus to meat production for domestic cities, and European dominance in the production of fine wool from Merino sheep in south-western Europe. Additionally, Waverley Abbey and its importance to the local wool economy had an abrupt ending when King Henry VIII dissolved the Abbey on 1536. All that remains are the atmospheric ruins hinting at its impressive past.

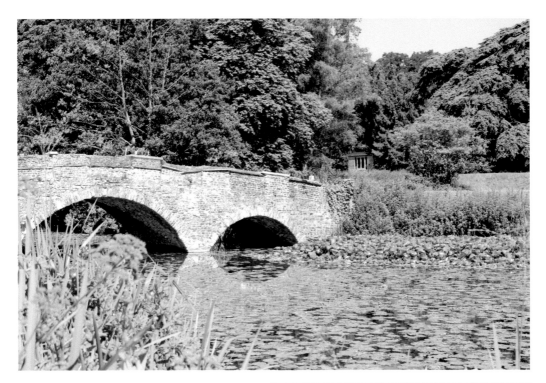

Above: The River Wey and the water meadows near the ruins.

Right: The ruins of Waverley Abbey are now protected by English Heritage. It is open to the public all-year round.

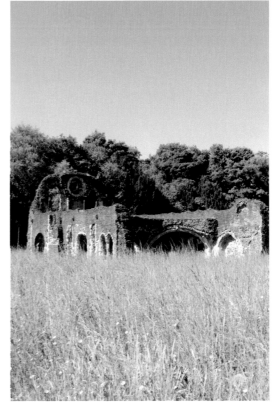

RURAL INDUSTRIES

AGRICULTURE

Most of Surrey and Hampshire was rural until the late nineteenth century and the majority of Farnham residents and its local villagers were involved in some way with agriculture and its associated trades.

Both wheat and hops were important crops for Farnham (the hop trade will be covered in the next chapter). Wheat was grown extensively in the local fields and the author Daniel Defoe (of *Robinson Crusoe* fame), writing in 1778 in *Tour Through the Whole of Great Britain*, stated,

> we came to Farnham, of which I can only say, that it is a large populous market-town, the farthest that way in the county of Surrey, and without exception the greatest corn-market in England, London excepted; that is to say, particularly for wheat, of which so vast a quantity is brought every market-day to this market, that a gentleman told me, he once counted on a market-day eleven hundred teams of horse, all drawing wagons, or carts, laden with wheat at this market; every team of which is supposed to bring what they call a load, that is to say, forty bushel of wheat to market; which is in the whole, four and forty thousand bushel.

In the nineteenth century much of the local population described themselves as 'agricultural labourer' on census returns. An agricultural labourer would work for a farmer who might himself be a tenant of a wealthy landowner. The life of an agricultural labourer was wretched in the nineteenth century. Today many of us aspire to own a traditional country cottage, but imagine what it would have been like in the 1840s: large families cramped into a two up and down, with no electricity, no running water or inside bathroom. Entire families foraged woods and country lanes for material to burn for heat and cooking. Anyone caught removing larger parts of trees such as a branch did so at their peril – this was classed as stealing and punishment was severe, such as prison or even transportation. Many would not be able to read or write. Hunger was a constant companion and people often had no more to eat than bread, turnips and potatoes.

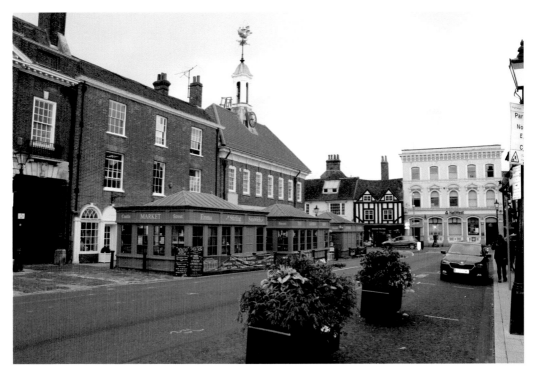

Above: Town Hall and Corn Exchange – opened in 1866 and designed by Edward Wyndham Tarn – where merchants would trade corn.

Below: Lower Church Lane. These buildings are now Grade II listed.

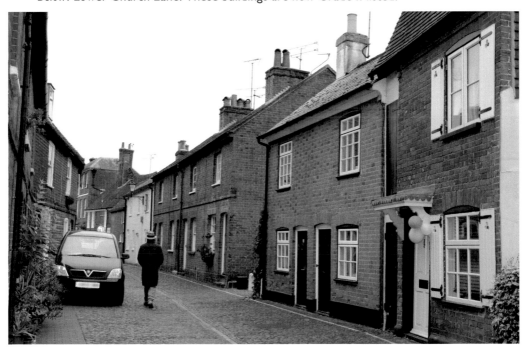

In 1799, 1800 and 1801 widespread rioting broke out throughout England. These were known as the Food Riots, provoked by scarcity and soaring prices during Napoleon's continental blockade of Britain. The cost of a loaf of bread was at an all-time high. The *Hampshire Chronicle* in 1800 reported,

At nearby Farnham the previous market day had exhibited symptoms of riot and threats were made that the 'country people' were to gather at the market on the 25th. As promised, they appeared, armed with large bludgeons, but the magistrates were prepared and, with the assistance of a small military force, went amongst the crowd removing their weapons and persuading them to disperse. (Cambridge Uni Press, 2021)

More riots followed in the 1830s, called the Swing Riots, in which agricultural workers in southern and eastern England engaged a widespread uprising in protest of the mechanisation of agriculture which threatened their livelihoods. Swing Riots occurred in pockets all over the county and neighbouring Hampshire had particularly aggressive rioting which would of no doubt inspired some labourers in Farnham. In 1830 letters were received by local farmers and landowners signed by 'Captain Swing' stating that if their threshing machines were not destroyed then riots could follow, and in at least one instance a furze stack was set on fire.

William Cobbett (1763–1835) was the son of Farnham publican and farmer George Cobbett but moved to London at nineteen to become a journalist. He began the *Political Register* newspaper in 1800 and it appeared almost weekly until his death in 1835. Cobbett played an important political role as a champion of traditional rural England against the changes wrought by the Industrial Revolution. He did much to highlight the harshness of early nineteenth-century farm labour. In his book *Rural Rides*, he expresses his concerns about the condition of the agricultural labourer and rural poverty. His article the 'Rural War' examined the Swing Riots and lay the blame with those who lived off unearned income at the expense of the rural poor, and he urged parliamentary reform. He was charged with seditious libel but argued the prosecution and was acquitted. Lord Melbourne, the then Home Secretary, was concerned that Britain was heading for revolution, so he treated the rioters harshly – 252 were sentenced to death (but only nineteen were hanged), 644 were imprisoned and forty-eight were transported.

Another Farnham observer was George Sturt (1863–1927) who wrote under the pseudonym George Bourne. He had the rural trade of a wheelwright, last of a family line who for several generations had carried on a small business in East Street, Farnham. He recorded his thoughts and the words of the working people he met and knew in the rural area of Farnham and the Bourne where he lived. Sturt describes the harsh realities for the rural poor such as the consequences of a poor harvest and the fear of the workhouse that overshadowed their day-to-day lives.

Farnham Workhouse was located between the modern-day Hale Road and Guildford Road. On 19 October 1867 the medical journal *The Lancet* published a damning report of Farnham Workhouse. It describe the building's gloomy, dark, badly ventilated, poor sanitary conditions and the food as 'nasty-looking'. The inspector continued:

in one of the yards we observed what looked like two rabbit hutches … with the ordinary furniture of frowsy straw and fastened with huge padlocks. These are the male and female tramp wards. The men are allowed no food at all, however weary or faint they maybe. The women are allowed a piece of bread if they have children with them, not otherwise….

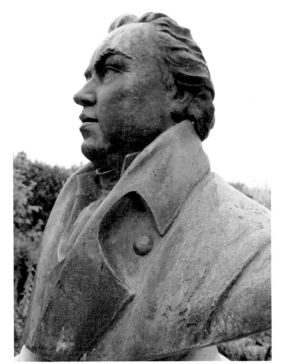

Right: Bust of William Cobbett at Farnham Museum.

Below: The birthplace of William Cobbett. Once known as the Jolly Farmer, it was renamed in the 1970s to honour the political writer.

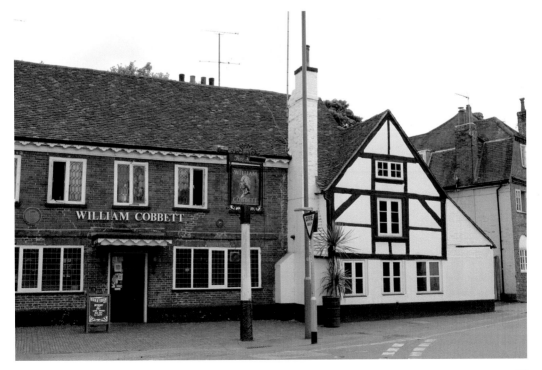

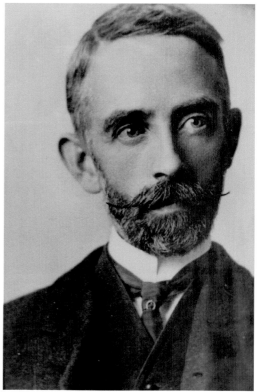

Above left: Location of George Sturts Wheelwright Business.

Above right: Image of George Sturt as a young man, displayed at Farnham Museum.

Farnham Hospital, once the site of Farnham Workhouse.

A female tramp known to be on the verge of confinement was locked up all night in the female hutch. When the porter unlocked the door at seven in the morning, the women had already four hours in labour.

The report concluded 'the existence of such places is a reproach to England – a scandal and a curse to a country which calls itself civilised and Christian'.

Towards the end of the nineteenth century there was a general agricultural depression, mainly due to the decreasing profitability of arable farming. Cereals, and especially wheat, suffered from marked price falls. Farnham agricultural workers, like many other rural areas, started to leave the fields and move to more urban employment.

BASKET MAKING

Although Farnham was inextricably linked with farming, there are a whole host of other rural-related activities which were the mainstays of Farnham and its villages' economy. Examples would be blacksmithing, wheelwright, coppicing and basket making. Whilst researching my family tree I discovered that my maternal ancestors lived at Crondall and were basket makers, which was one of Crondall's chief industries due to its osier bed where willow was grown. Basketry is one of the oldest crafts in the world, even predating pottery, and baskets were an everyday life essential used for containing, storing and carrying items. Harvesting the willow was arduous work. Local women would be employed to cut the osiers with a hook. Then the osiers had to be sorted into their various lengths and lateral shoots towards the top had to be trimmed off with a sharp knife. This sorting was done by

S. F. Cody and one of Stevens' baskets.

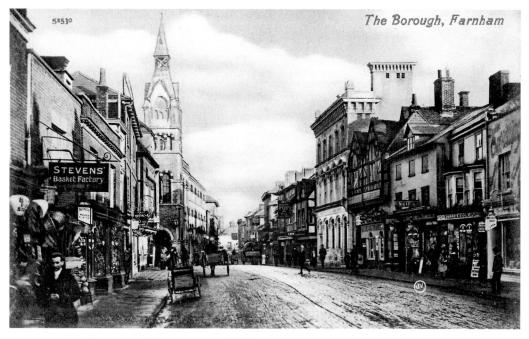

Stevens Basket Factory in The Borough, 1905 Frith Series.

two or three women. As soon as a fair number of bundles had been sorted, they were stood back in the pond till collection. Stripping osiers was done by hand and was a piecework job, and not pleasant as the work could be damp and cold. The basket makers would have worked often in their own cottages sat on very low stools with their backs to the wall. Their hands were their main tools, plus a very sharp knife and a mallet. The local basket factory was run by Daniel Stevens, who started it around 1795 and ran till the late 1930s, and he had a shop in Pankridge Street, Crondall and also The Borough, Farnham. Apart from baskets Stevens made armchairs, tables and even hot air balloon baskets for S. F. Cody for his flights at nearby Farnborough in the early 1900s (Crondall Society Chronicles, Spring 2017). The introduction of plastic in the 1950s led to a decline in the willow basket trade.

GRAVEL AND SAND PITS

On a national basis quarrying has traditionally been probably second only to agriculture as a source of rural employment. Gravel pits were one of the country's oldest sources of raw material for roads and buildings. The Romans dusted their roads with gravel, later settlers used it as ballast for ships, and by the late eighteenth century local authorities were also claiming it for road repair. Today the whole of the construction industry depends upon plentiful supplies of sand, gravel and crushed rock. Houses, schools, roads and countless other building needs all require aggregate.

The coming of the railway in 1849 made transportation of gravel and sand easier and much land in Farnham, including ex-hop fields, was given to this profitable industry.

Jobs at the pits required little skill and so were easily accessible to anyone. In the Farnham area it was usually local workers who worked at the pits. They often wore corduroy

trousers, a small leather strap worn around the trouser leg used to hold Man, which was a small spade-shaped piece of wood used for cleaning sand or soil from a shovel. It was filthy work and by the end of the day the clothes would be covered with dirt. The work was irregular, as rain, snow and frost would stop work as it became too difficult. It was normally poorly paid and out of their wages the men would have to buy or repair tools.

An 1811 Book of Trades puts the journeyman bricklayer's wages at four to five shillings a day, the paviours, who fix the roads, at three shillings and tenpence a day, and his labourer two shillings and eightpence. The labourer's wages were only marginally better than those recorded by William Dunlap, a visitor to England in 1786, who reported a conversation between his travelling companion and two gravel workers. The doctor, Dunlap writes, began by observing,

> What happy people the English were, to which they agreed & seemed proud of the idea of being happier than the people of any other country in their station, being perfectly content though hard at labour in a damp gravel pit for the sum of 13 pence per day, out of which they found them-selves, clothing provision.

As the conversation proceeds, however, it turns out they aren't so merry after all as one has a spouse who is out of work and his 'scanty wages' are hardly enough to maintain both of them.

Once pits were depleted, nearby residents abandoned them and let nature take its course. Tices Meadow, located between Badshot Lea and Tongham, is a newly developed nature reserve on the site of the former Farnham Quarry. The land now forming Tice's Meadow

Along the railway at Wrecclesham and Weydon Lane there are still several operational gravel and sand pits.

was owned and farmed for hops by Henry Tice. In 1973 the Tice family sold a portion of their land to Pioneer Aggregates, the 140-acre quarry operational between 1998 and 2010. The site is now widely considered one of the best inland sites to watch birds in the south-east of England.

The developments of the pit areas make it hard for us to realise how much of the local land in Farnham was used for this industry – thousands of tons have been removed. For example, in 1897 Farnham Flint, Gravel and Sand Company started selling their land off as plots of empty tract with patches of gravel pits and heather-covered heathland. Due to its sandy soil, these plots were used for housing. This became known as Great Austins.

Laurel Grove, Boundstone. There were once sand pits along this lane and sand martins would build their nests in them.

HOPS AND BREWING

HOPS

Beer first arrived in England in 1400, at Winchelsea harbour in East Sussex, by Dutch merchants who were trading in England and couldn't travel without it. It quickly caught on and by 1412 beer was being brewed in England. One of the main ingredients was hops, which makes the beer taste better and keep longer. English farmers soon realised the importance of hops. Kent was the earliest centre of hop growing in England but by the late 1500s Farnham, with its strong, well-drained loam soil, had also started to grow hops.

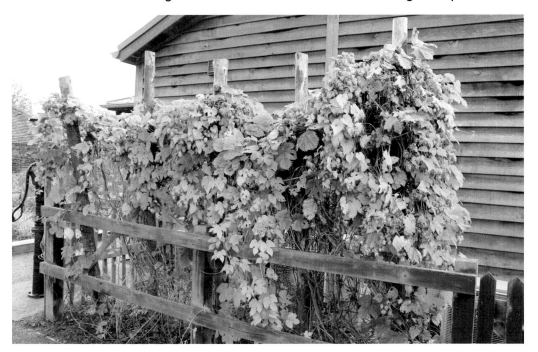

Autumnal hops, Farnham Museum Garden.

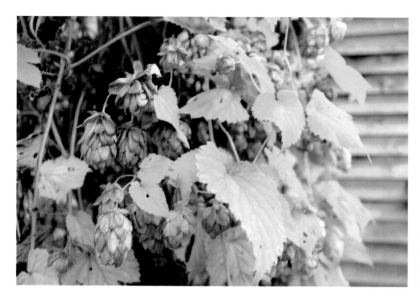

Autumnal hops, Farnham Museum Garden.

The diarist John Aubery recorded in *Perambulations of Surrey* in 1673.

> Farnham there are hops in as great plenty as in any part of England. Old Mr Bigmnall's father was the first that planted hops here, which husbandry he brought from Sussex 76 years go and since they have planted ever larger quantities so that now about this town are no less than 300 acres of hop yard.

Another writer, William Gilpin, recorded in 1775,

> From the terrace of the castle we overlooked what may properly be called the Vale of Hops for we saw nothing but ranges of the plant ... The value of the hops spread under our eyes was supposed to be at least £10,000 (over a million today).

By 1800 there were more than 1,000 acres of hop garden in and around the town and six breweries and seventy hop planters and dryers. The population was 5,800.

V. D. O' Rourke in *Hop Growing and it's decline in the Parish of Farnham 1873–1973* states that in 1750 a new strain of hop was introduced to Farnham Growers by a Mr Peckham Williams of Badshot Lea. This was a Whitebine Grape Hop. These Whitebines were the most prized hops in Britain and attracted a premium prize which fetched often a third or even double more than other hops.

In spring, late enough to avoid a frost, the hop yards around Farnham would be awash of bare wooden poles approximately 3 inches in diameter and 15 feet tall. Around the base of the poles women would plant hop cuttings. Men on stilts would walk between the poles and would string wire across the top of them. From April onwards, the hops were twiddled (tied) or trained onto each string. Depending on the variety, either two or three shoots were tied, clockwise, to each string. If they were tied anti-clockwise, they would fall off.

By June, the plants were starting to establish themselves on the strings. By the middle to end of July, the hops would have reached their full height and the laterals began to grow out. When the days started to shorten after solstice the hops were triggered to burr and the hops developed.

Above: Former hop kilns, Bear Lane.

Below: Former hop kilns, Park Row.

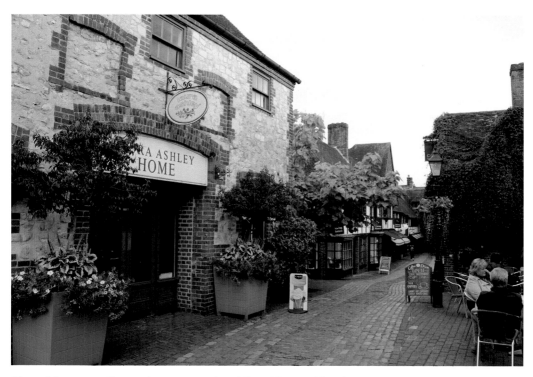

Above: Now a retail store but once an hop kiln – Lion and Lamb.

Below: Coxbridge Farm, a wonderful example of a hop kiln.

By early September the hops were ready to be picked. School holidays were arranged to fit in with the harvest. Extra labour was needed and hop pickers arrived from London and other areas. For many of these casual labourers it was their only 'holiday' – a chance for a spell in the countryside and some fresh air. They would arrive on carts with children, prams, bundles of bedding and clothing, pots and pans. It was hard work but often enjoyable as a change from the smoke of London and the children had a chance to play, messing about in streams, finding wild rabbits, playing cards and lying-in hammocks that were hooked up between hop poles.

Hop barracks where dotted around Farnham and villages – Wrecclesham alone had five. Not all farms provided adequate housing. There was often no water supply, damp and nothing but sack curtains to separate sleeping quarters. In 1899 the Bishop of Winchester begged the council to secure decent housing for the hop pickers. This letter from a Henry T. Taylor to a London newspaper in 1867 describes the squalid living conditions:

Several families composed of men, women and young boys and girls lodged together in a large barn, the dilapidated roof of which and floor of damp earth gave little promise of comfort in rainy weather. Their beds were made of musty straw that had probably been refused as unfit for littering the farmer's horses while some tattered shawls hung on a line to screen the several groups from each other. In one corner, a weakly child had just died, almost unheeded, from the effects of wet and exposure. (Wrecclesham History Society)

An old hop pickers barracks. Note the hops growing – a hint at its past history.

Above: An ex-hop pickers barracks – now private housing, Wrecclesham.

Below: Painting of nineteenth-century hop pickers, Farnham. (Wellcome Collection)

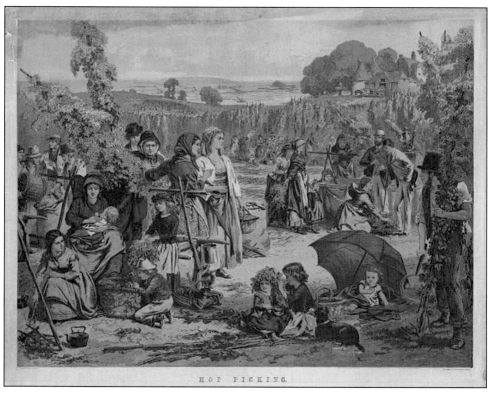

Hop picking was done in rain or shine. It was an early morning start and a sunset finish. The pickers would wear their oldest clothes as the sticky granular covering the bines stained hands and garments. Once at the hop gardens the pickers collected their numbered basket, and the picking began.

First of all, the hop bines had to be pulled. This entailed tugging at the strings up which the hop bines had grown until they came crashing down. The bines were then slung across the baskets which were placed across the 4-foot passageway between the rows of poles. The picking then began in earnest with the children sometimes having their own bine. The baskets had the capacity for seven bushels of hops. Singing was a way to keep entertained.

A pole puller, who carried a long pole with an iron hook on the top, patrolled the gardens. Sometimes when a bine was pulled the string would break leaving a bunch of hops near the top of the pole which needed to be pulled down. During the day the seven-bushel basket became full and was emptied into a sack which had been distributed by the pole puller. Once work finished the sacks were dragged to the end of the row, where the tallyman would count the number of bushels picked and then notched on a piece of wood called a Tally. Then, the sacks were emptied into a huge metal tub to be weighed. It was most important that the weights were correct as the payment depended on them.

The hops were then taken to local kilns to be dried. Drying was a skilled job as the price of the hops received by the farmer was determined by the quality of colour, flavour (smell) and moisture content. The hops had to be of an exactly calculated dryness otherwise they would fetch a poor price. The indication that hops were ready to leave a kiln was that they were brittle and crumbled in your hand when rubbed.

In the kiln the heat from furnaces below would rise through a lattice drying platform on where the hops are spread for approximately fifteen hours. Air was drawn through ventilation holes at the foot of the kiln walls. The moisture of the hops fell from 8 per cent to less than 10 per cent during drying, leaving them brittle. In other areas like Kent, sulphur was added to improve flavour and colour, but this was an unhealthy practice and Farnham dryers chose not to use it. After drying, the hops were transferred to a cooling floor and then bagged into long bags called pockets. Farnham pockets were stamped with a particular design, usually including a bell. The closer you grew them to the best soil, the more bells you could display.

The sacks were suspended from a hole on the cooling floor and a bagster climbed into the sack and the hops were tipped onto him whilst he trod them down. The bagster wore flat shoes and a large hat for this dusty task. Then the bags were sewn up – known as coping.

Hop drying went on continuously in the hop picking season – picking and drying had to keep pace with each other.

The earthy aroma of the drying hops would have floated across the town. Once finished the sacks were transported to breweries or the annual Weyhill fair. Such was the value of hops that one Farnham hop grower, James Stevens, had an armed servant with him when he attended Weyhill fair. Fellow hop farmers subsequently entrusted their money to him as well. Stevens decided to start a bank with the purpose of engaging in paper transactions – i.e. cheques rather than the carriage of cash – and this eventually led to Stevens Bank in Farnham, one of Farnham's first banks.

Hop picking and drying season in September dominated Farnham, and the hop pickers partied hard with reports of drinking and fighting outside pubs. Marshall, writing in 1798, claimed that the finishing frolic better than Kent as the pickers dressed up and paraded through town the streets with a fiddle 'singing and shouting in tunes of true licentiousness'.

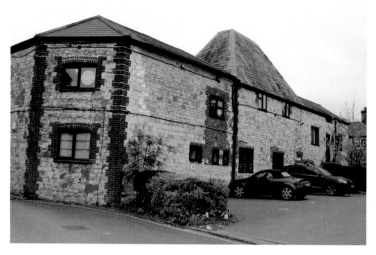

The Oast House, Mead Close. Notice the central rectangular kiln. There was a loading floor on one side and a cooling bagging room on the other.

Arundell Place. This is a former factory where hop bags were manufactured.

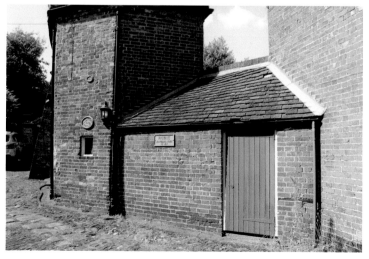

Malthouse Yard. This yard used to lead to hop fields that were behind it. The tower-like building was a Tally mans' office, where he paid the hop pickers.

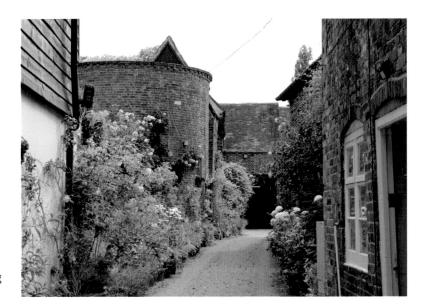

Hones Yard, Downing Street. The round building is a kiln.

Long Garden Walk. Here rope was manufactured for the hop trade. Two men would walk backwards with the rope between them. They twisted the strands while a third man used a marlin spike to pack strands tight.

The area of hops in Farnham increased until 1875 when it peaked at 1,592 acres. General decline followed as demand from brewers dwindled, and a row of wet summers from 1875 to 1884 caused many hop growers to give up. Another bad summer followed in 1915. In the 1920s downy mildew arrived, which spelt the end of Farnham Whitebines. The Whitebines were grubbed up and replanted with Fuggles, which were popular but not premium. The last Farnham hop ground at Holt Pound closed in 1976. The old hop land was used for other crops, quarrying or housing. Fields around the town that were once used for the hop industry were used for housing and by get-rich-quick developers, for example Peckham Williams (of Whitebine fame). In 1926 hop ground at the rear of East Street became housing known as Stoke Hills. Hale and Badshot Lea went the same way, as did many others.

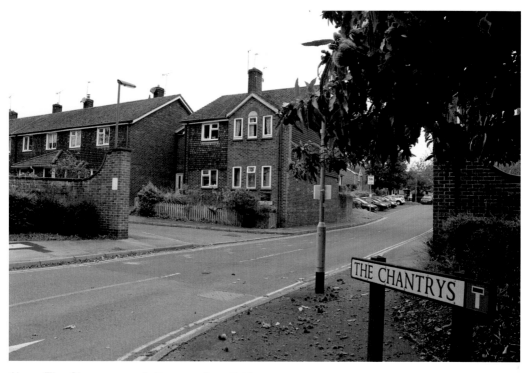

Above: The Chantrys was built on ex-hop fields.

Below: Waynflete Lane is just one example of mass building that happened in the 1920s after the decline of the hops in Farnham.

BREWING INDUSTRY

By the late 1890s and early 1900s the brewing and malting industries were a major source of income in Farnham. Local farmers produced barley, the major grain used in beer, which was passed on to local maltings to be roasted.

First, the barley is screened to remove impurities, then steeped in water for up to seventy hours, allowing germination to begin. The grains are then spread on the malting floor and raked and turned to maintain an even temperature and stop the shoots gathering together as germination takes place. After eight to fifteen days, the part-germinated grains are moved to a kiln and then dried for three to five days, adding flavour and colour. These processes take place in traditional floor maltings or from the late nineteenth century by pneumatic maltings. Finally, the husks are removed and dispatched to brewers.

Farnham is fortunate in that it has a fine example of a malting building that has survived since the eighteenth and nineteenth centuries. Farnham Maltings was originally not one building, but at least two separate properties. The Farnham Trust Society explains that the earliest records for the South Wing, the part of the building adjacent to Red Lion Lane, show that it was being used in the 1750s as a tannery, by Michael Reading and which his niece inherited in 1761 and sold in 1770 to Stanley Bolan. Bolan became bankrupt in 1802 and was forced to sell for £530 to pay his creditors. In 1845, the buildings were sold to John Barrett for £1,400. He converted them into a brewery and when the army arrived in Aldershot in 1850s he opened pubs all over Farnham. By the 1870s he was rich enough to extend his property by constructing the buildings along the riverfront.

At this time, the East Wing was a separate building. In 1830 it was bought by Robert Sampson, who set up as a maltster. Business was booming and in gratitude the Sampson family in 1845 gifted five existing cottages in Mead Lane for use as almshouses. Robert died in 1863 and the business passed to his son, who went by the memorable name of Sampson Sampson.

In 1881 John Barrett bought out Sampsons but nine years later the malting was bought by George Trimmer, who was the owner of the Lion Brewery. He amalgamated his own group of pubs with those of Barrett which gave him around ninety-one plus eight off-licences. The business was known as the Farnham United Breweries. George Trimmer would do the malting process at the Maltings and then brew the beer at the Lion Brewery in West Street. Trimmer died in 1892 leaving the Maltings to his family, who in 1903 further extended and improved the riverside buildings and installed the latest malting equipment.

Courage Breweries took over the Farnham United Breweries in 1925 and the Malting continued there until 1956, when the development of newer, cheaper methods of malting made it uneconomic for the brewery to continue to use it.

The building then stood abandoned and fell into disrepair. However, Courage ultimately offered the Maltings to the town for £30,000 and today, after many years of fundraising and campaigning, it is now a leading South East community centre.

The basic principles of brewing have changed very little over the centuries. At the brewery the malt (usually made from barley) is milled and ground down into grist, ready for mixing with water, which is known to brewers as liquor. Hot liquor and grist are mixed together in the mash tun—a large, cylindrical vessel.

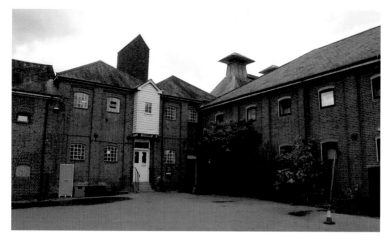

Farnham
Maltings – with a
brewing history
dating back to
1845.

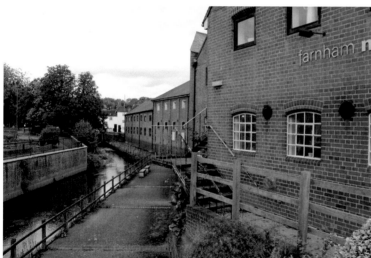

Farnham Maltings
next to the
River Wey.

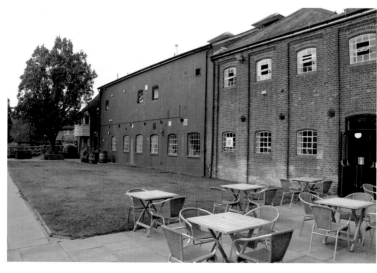

Farnham Maltings.

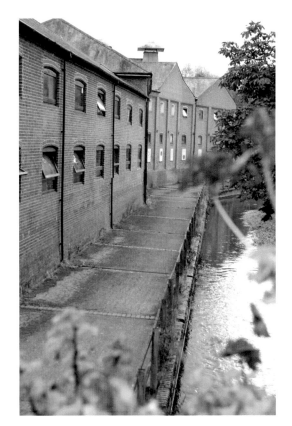

Right: Farnham Maltings along the River Wey.

Below: The almshouses in Mead Lane were replaced in 1934. These five new almshouses were built nearby in West Street.

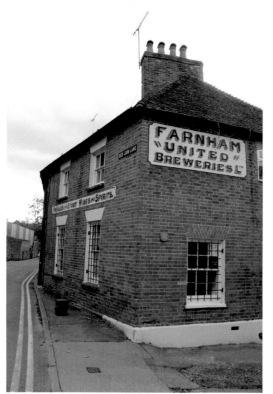

Above: Sampson Sampson's sign can still be seen on the edge of his cottage at 18 Bridge Square.

Left: A restored sign for United Breweries which can be seen on the side wall of No. 2 Red Lion Lane, which until 1920 was the Red Lion pub.

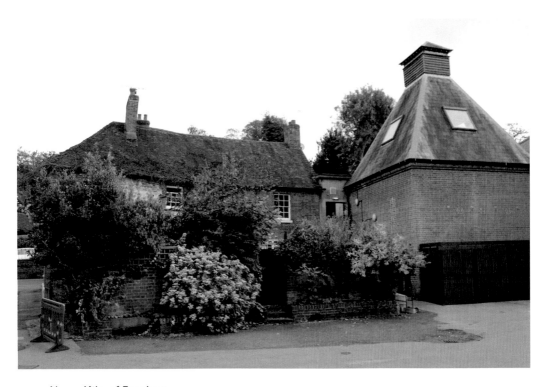

Above: Kiln of Farnham Maltings, part of the extension by George Trimmer.

Right: The south-west kiln of Farnham Maltings.

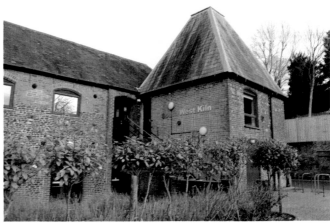

The thick, sludgy mix is then allowed to stand for two or three hours at a controlled temperature, which converts the grains into sugars which dissolves to a sweet liquid mix known as wort. The wort is then boiled with hops in a large metal vessel known as a copper. After boiling, the hopped wort is sent through a metal vessel with a perforated base, the hop back, which sieves out the spent hops and allows them to cool. Fermentation then takes place. Originally large, open shallow tanks were used for this purpose, sited near the top of the brewery tower where good ventilation was available. Yeast is added and within twenty-four hours the surface is covered with a thick yeasty foam, which is later skimmed off. It then ferments for around three days. Finally, the beer is either bottled or run into casks (racked) and kegs.

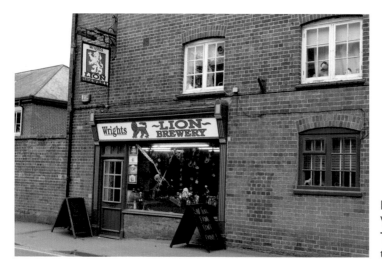

Lion Brewery in West Street. George Trimmer brewed on this site.

The Memorial Hall was built by the owner of Farnham United Breweries in memory of his six employees who died in the First World War.

Farnham Museum was built in 1781 by John Thorne, a maltster and hop merchant. This is an example of the wealth created by these industries.

THE ARRIVAL OF THE RAILWAY

Prior to the arrival of the railway, Farnham had been an important stop for stagecoaches making the journey to London. There were several inns providing stabling, such as the Bush Hotel and the Lion and Lamb. Coaching inns were usually built around a central courtyard and stables with a tall gate leading to the open road – you can still see these characteristics today at The Bush Hotel. I can remember on a school trip to The Bush back in the late 1970s being shown wooden blocks in the courtyard – this was so that the hooves of the horses would not wake the sleeping guests. Saying that, it would be hard to get any sleep anyway though, as horns would be blowing to announce arrivals and departures. Also, you were not guaranteed your own bed as you would be expected to share a bed with a stranger if there was no spare room available. Coaching inns declined with the arrival of the railways.

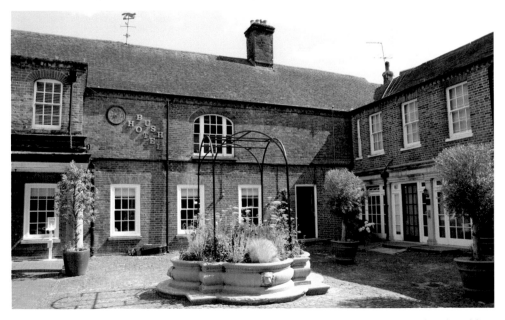

The Bush Hotel has been welcoming guests since the seventeenth century and is the oldest hostelry in town.

The London and South Western Steam Railway reached Farnham on Monday 8 October 1849. With the new station came new employment opportunities. Labourers (navvies) were needed to provide the gravel workings and plate. The word 'navvy' came from the navigators who built the first navigation canals in the eighteenth century. By the standards of the day, they were well paid, but their work was hard and often very dangerous. Navvies and their families lived and worked in appalling conditions, often for years on end, in wooden huts alongside the bridges, tunnels and cuttings that they built, including many of the railway lines in Surrey. Their work was extended when the extension of the single track from Farnham to Alton (Alton train station was opened in 1852) created more labouring jobs to work on the rail and to build three new bridges, at Wrecclesham Road, Weydon and River Lane.

Farnham station soon grew in size and individual local carriers found their business increased as there was a demand for goods to be taken to and from the station. Sidings covered the present car park and also the area on the south side of the station now developed as Southern Way.

Not everyone was glad to see the arrival of the railway. Ewbank Smith in his book *Victorian Farnham* describes how the South Western Steam Railway was threatened by the local authority board for causing public health concerns arising from the heaps and trucks of manure, putrid fish and decayed vegetable matter collected in piles close to the platforms at the railway station. The railway agreed that additional sidings would be provided. In 1893 Henrietta Halton of Waverley Arms claimed that she had been seriously ill with blood poisoning due to stenches from unloading fish and blood manure.

There were also petitions to stop the level crossing as there were accidents with the train and then the gates were unable to be open, stopping people from crossing the road. The solution was to build a bridge, but there were no side panels and Farnham residents were not prepared to use it.

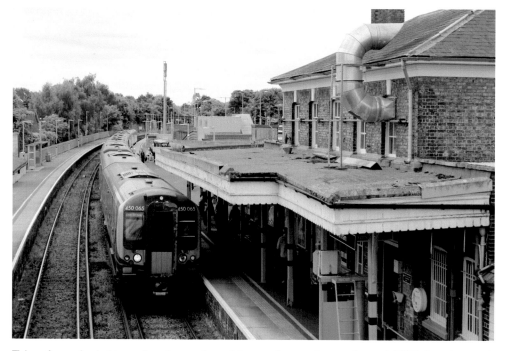

Taken from the bridge – London train waiting to depart. It wasn't until 1937 that the track became electrified.

The long-awaited for bridge, built in 1878 and panelled in 1881.

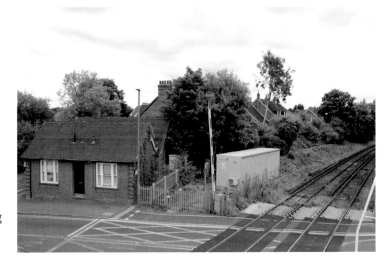

Raised level crossing next to ex-signal box.

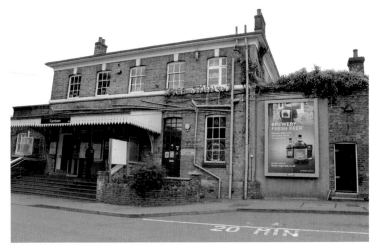

Front of the station. It has not changed hugely from when it opened in 1849.

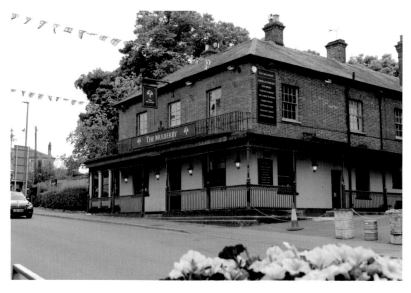

The Mulberry, built mid-nineteenth century to capitalise on the station. It was formerly known as the Blue Boy.

The arrival of the of army in Aldershot in 1855 changed the face of Farnham. Aldershot was a small hamlet with no pubs and no railway. At the time of the 1851 census the population of Aldershot was 875. By 1861 this had grown to 16,720, of whom 8,965 were soldiers. Farnham became more of a garrison town with many new pubs opening. There was an increase in fleets of horse buses between Farnham station and the army camp. At that time the way to the station was from the Borough, via Downing Street, on to Abbey Street and then up to the station. This was a convoluted route and pressure grew for a more direct road to the station. South Street was constructed for this purpose and opened in 1870, the same year that Aldershot opened its own railway station.

The new railway also brought travel opportunities for Farnham residents. For one penny a mile, by third class, inhabitants of Farnham could easily travel the 35 miles to London. Later, the extension westwards put Winchester and the south coast within easy reach and day excursions became a modern pleasure.

Also, an enormous change was the employment opportunities for the working Farnham man. Once people worked where they lived. But the railway changed all that. London, like other cities, grew and people flocked to them for work that was better paid than the work in the field. The downside was that these cities became filthy, overcrowded and polluted. So, from the latter part of the eighteenth century into the Victorian era, those who could afford it started to move out to new suburbs and even the countryside beyond, such as Farnham, and commuted to their jobs. In 1801 the population of Farnham was 4,321, making it a fair-sized town. Farnham grew rapidly during the nineteenth century and by 1851 the population was over 9,000. By 1901 the population of Farnham was 14,541 and by 2020 the population was 27,000, according to the Office of National Statistics.

In the last few years commuting has undergone a rapid change. The roots of this change lie with the coronavirus pandemic. Rail passenger numbers have fluctuated from being deserted at the start of the pandemic to between 60 and 70 per cent of pre-covid levels now. Only time will tell if the South Western Railway comes packed again with bleary-eyed Farnham residents making the early morning fifty-five-minute commute to London Waterloo.

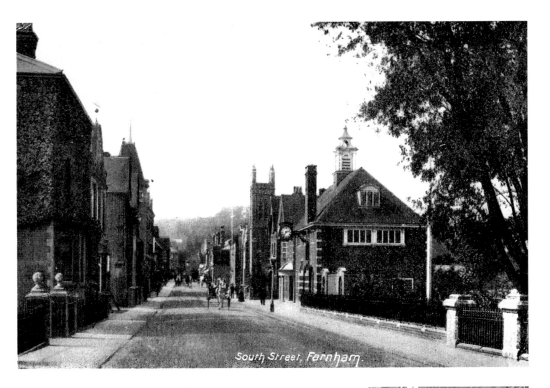

Above: South Street. Frith Series, early 1900s.

Right: The Town Hall, South Street.

South Street, July 2022.

Left: Flower display outside Sainsbury's to honour the great residents of Farnham.

Below: Display from Farnham Museum.

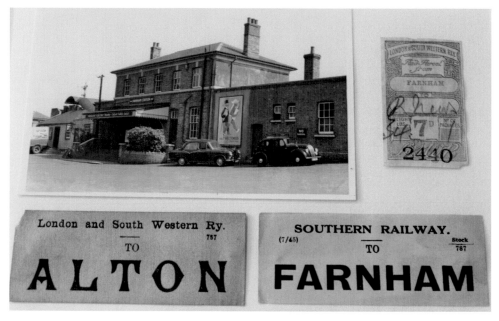

MANUFACTURING

John Henry Knight is Farnham's most famous, and some may say eccentric, inventor. Born in 1847, he was the eldest son of a long-established banking and brewery Farnham family. When he was sixteen, he moved to Southampton to study, where he would often visit Southampton's large locomotive sheds and look around engine rooms of the P&O ferries, which influenced his decision to become an engineer. Knight started an apprenticeship with Messrs Humphrys & Tennant, marine engine builders in Deptford, and once completed he returned to Farnham. At twenty-one he began building a steam carriage nicknamed *Steamer*, but it did not go according to plan as it had no brakes, often broke down en route and then had to be returned home by horse. Knight decided to sell the *Steamer* in 1877 and concentrate on other projects, such as a series of grand tours, farming and property. Knight even tried growing tobacco in Farnham but was not successful due to it being labour-intensive and requiring large investment for drying sheds, steam equipment and a press.

In 1888 he moved to new house called Barfield in Runfold with his new wife and young family. The house gave him the space to continue his love of inventing and in 1889 he found success with the *Trusty Oil Engine*. It ran on paraffin oil and petroleum and was exhibited at the Royal Agricultural Show at Windsor. It was patented around the world and won awards at the 1893 Great World Fair in Chicago.

Knight, helped by engineer George Parfitt, then went on to build a single-cylinder, 1565cc, two-seater petroleum tricycle. Some argue that it was the first petrol car to be driven on public roads in Britain and according to the National Motor Museum, more records exist for John Knight's 1895 three-wheeler than for any other petrol-powered vehicle of that time.

It was this vehicle that led John Henry Knight to have a brush with the law. At the time, Britain's road traffic laws dated back to the 1860s and placed considerable limitations on the use of heavy steam-powered vehicles. Inventors like Knight had to deal with the anti-machinery attitude of the public and the opposition of the horse coach interests, which resulted in such penalties as a charge of £5 for passing a tollgate that cost a horse coach only three pence. The crushing blow was the Locomotives on Highways Act of 1865, which reduced permissible speeds on public roads to 2 miles (3 km) per hour within cities and 4 miles (6 km) per hour in rural areas. This legislation was known as the Red Flag Act because of its requirement that every steam carriage mount a crew of three, one to precede it carrying a red flag of warning.

Knight believed that Parliament was stifling the development of the motor car. Did MPs not understand the individual mastery that came with driving, or the exhilaration of speed

George Elliott's
Reliance Works in
50 West Street.

whilst enjoying fresh air and the change of scenery? In a plan to raise the profile of the benefits of motoring he hatched a PR stunt: on 17 October 1895, Knight got a friend (as his own arm was in a sling) and his assistant, James Pullinger, to drive around Farnham, attracting the attention of the police who eventually flagged them down in Castle Street. John Knight, even though not in the car, admitted responsibility.

A crowd gathered to hear the police superintendent ask if the vehicle was a steam engine. When John Knight replied that it was not, he and James Pullinger were charged with using a locomotive without a traction engine licence and without having someone walking in front of the vehicle waving a red flag to warn pedestrians. Additionally, the vehicle was being driven between the local restricted hours of 10.00 a.m. and 18.00 p.m. The case was heard at Farnham Petty Sessions at Farnham Town Hall on 31 October 1895. Knight and Pullinger were both fined approximately 2s 6d plus 10 shillings costs. Knight was restricted to using the car only on farm roads. Although his car was travelling at speeds of up to 9 miles per hour, Knight was not the first person in England to be charged with speeding, as is sometimes reported – the first successful prosecution in Britain for this took place a few months later against William Arnold of East Peckham, in Kent. Despite being fined, Knight welcomed his prosecution, using his appearance in court to highlight the absurdity of applying existing legislation to a light car which was clearly not a traction engine.

In 1896 new road traffic legislation quickly followed. A new class of vehicle, the light locomotive, was defined and the speed limit raised to 14 mph. The requirement for someone to walk in front of the vehicle was also removed. This new legislation was celebrated by an emancipation run from the Hotel Metropole in London to the Metropole in Brighton.

In 1896, Knight revised the engine in his car and altered it to a four-wheeler for greater stability.

Knight continued to support motoring by becoming a founder member of the Automobile Club, later the RAC, hosting the first ever members' club run at Barfield House.

His inventions didn't end there. Knight found that rubber tyres wore out quickly, so made tyres from strips of ash woods with carrell cuts to them to make them springy, but the tyre never caught on. During the First World War Knight designed a Grande launcher built in 1915 at Reliance Works and demonstrated in a meadow his trench bomb thrower which lobbed a two and a half bomb over a distance of up to 130 yards – but this wasn't taken up

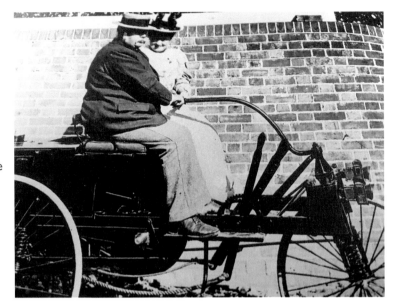

Right: John Henry Knight and his wife Elizabeth aboard his petrol car, 1895.

Below: Wooden Vehicle Tyre. (Farnham Museum)

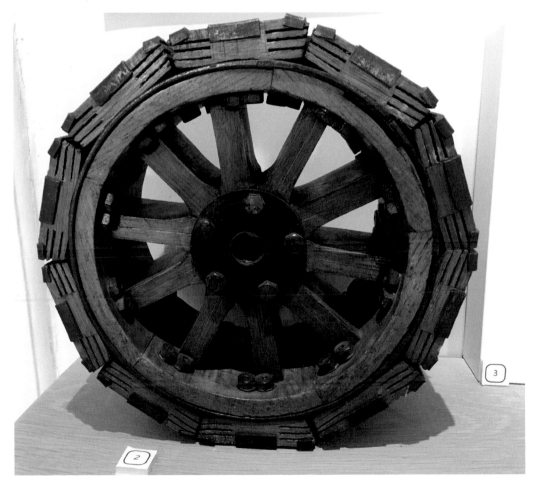

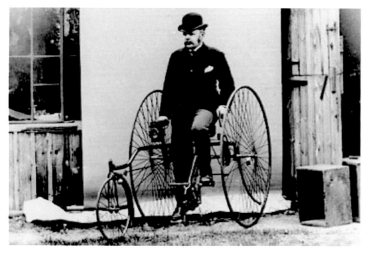

John Henry Knight on his Invincible two-track roadster, 1892. (Farnham Museum)

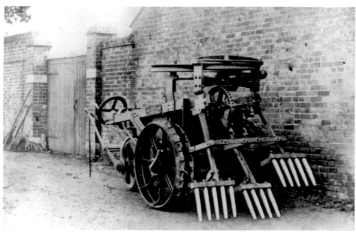

Steam-powered hop picker.

by the army. There was also a patented 'dish lever' for tilting plates when carving meat and a brick-laying machine that could not turn corners. He died before the end of the war on 8 September 1917 and is buried at St John's graveyard at Hale.

ABBOTTS

Edward Dixon Abbott was born in 1898, educated at Eastbourne College and joined the Royal Naval Air Service in 1917 where he was posted to France. He took part in a number of air combats and was unfortunately shot down over France in 1917. He was badly injured and was taken prisoner of war. He was repatriated in December 1918 and retired from the RAF in January 1920. In 1926 Abbott made the move to Farnham and joined the coachbuilder Page & Hunt at their factory in Wrecclesham. He was employed as P&H's Design Consultant and London salesman. The post-war recession hit P&H badly and the business went into liquidation in 1928. The ever-tenacious Abbott bought the business and placed his name on the store front. He created a second-hand car sales department and a Servicing and Repairs' workshop and from 1931 Abbott took a stand each year at the London Motor Show.

During the early hours of 30 December 1935 an intense fire broke out in the sawmill and due to the combustible nature of the wood, it spread quickly to the body shop. Nearly forty cars, including two Rolls-Royces and a Daimler, were destroyed. The damage was estimated at between £18,000 and £20,000 but Abbott was a determined man and quickly erected temporary buildings while the factory was rebuilt.

Despite this drawback, the company grew, and Abbotts won contracts to body Talbots, Fords, Lagonda Rapier, Aston Martin, and the Frazer Nash-BMW, and in 1937 the elegant Atalanta. The Atalantas were very expensive and had the style of a racing car. Alas, the outbreak of war stopped production after only twenty cars had been built. As well as these luxury brands, Abbotts also did bodies for more mundane vehicles such as local bus and coach companies.

During the Second World War car manufacturing was put on hold. Despite this, Abbotts played its part in the war effort by manufacturing airframe components such as an engine cooling system for Spitfires. During this time the Abbott workforce had grown from 110 employees to around 400, many of them female.

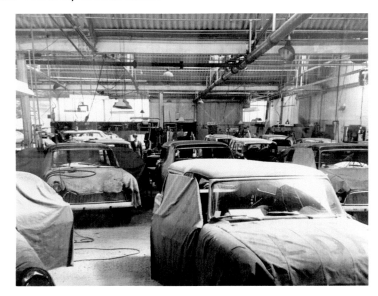

Inside E. D. Workshop, 1960s. (Farnham Museum)

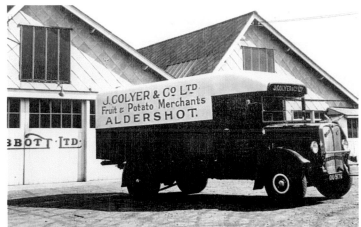

Delivery van outside Abbotts, built on A. E. C. Mercury chassis. (Farnham Museum)

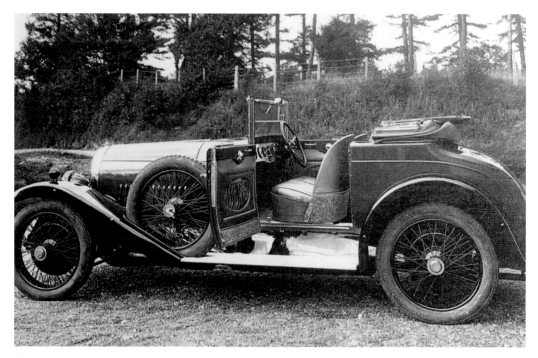

Chassis by Bentley, bodywork by Abbotts, 1930s.

After the war an order was secured by Abbott for the design and body production for the Abbott Healey as well as continuing with building bespoke Rolls-Royce. Customers included the rich and famous, such as David Lloyd-George and Rudyard Kipling.

Abbott retired in 1950 and sold his company to R. Gordon Sutherland, former MD of Aston Martin. Sutherland kept the name Abbotts of Farnham and business continued. A popular local tale is that it was one break time, just after Sutherland begun, that the Abbotts designer Peter Woodgate doodled the back end of an estate car onto a Ford Zephyr Mk1 Saloon brochure which was shown to Sutherland. Sutherland liked the design so much that he bought a Ford Zephyr Mk1 saloon to convert into an estate car. The conversion was shown to Ford in Dagenham, who gave it their approval. A major contract was negotiated with Ford to convert larger models from their range into estate cars beginning in 1953 with Consuls, Zephyrs and Zodiacs. At this time, it was not practical to integrate estate bodies into the normal Ford production line, so complete cars were shipped down to Wrecclesham where they were cut down and rebuilt as estate cars. The Ford estates were well received, and the company expanded. The 1950s was a decade of expansion. Then by 1966 the demand outgrew Abbotts, and the manufacture of the estate cars was moved to assembly lines at Dagenham. The early 1970s was a time of poor industrial relations in England which led to a three-month strike in the summer of 1971 at Dagenham. This meant a shut down in its production. Even though this strike had no direct impact on Abbotts, it highlights the challenges of car manufacture at this time. Abbotts, having no other business to fall back on, went into liquidation in 1972.

In 2019 Abbotts of Farnham was selected to be recognised with the Red Wheel heritage plaque, awarded by The Transport Trust, a national charity which commemorates Britain's rich and globally important legacy in the development of transport.

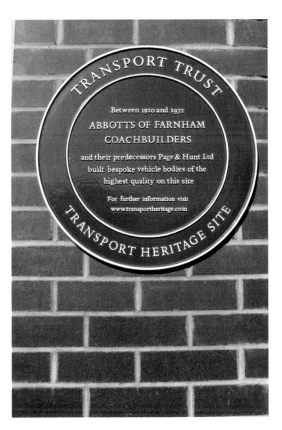

Right: The Red Wheel plaque that was awarded to Abbotts.

Below: The site where Abbotts once stood, Wrecclesham. Two of the cars converted by Abbotts are now property of the Queen. One is a 1956 Ford Zephyr estate, the other a 1959 Vauxhall Cresta estate.

CROSBY DOORS

No book about work in Farnham would be complete without mentioning Crosby Doors, which was Farnham's largest employer in the 1970s and 1980s. At its peak it manufactured 2.5 million doors a year.

During the Second World War it employed 1,000 staff and the normally produced wooden doors were suspended. Instead, the company carried out a government contract to produce ammunition boxes, detonator containers, aeroplane cases, pontoon bridges and radio vans. During this period the works spilled out onto the river meadows behind. It was not until the 1960s when site of the old Lion Brewery Works was demolished that Crosby Doors could expand its buildings.

The 1970s was a unique time for jobs. There was a push for more workers' rights, better working conditions and better pay. During this time, though, women still gravitated towards jobs that were traditionally carried out by women, and many of these such jobs at Crosby Doors were in the typing pool or secretarial department, while men held traditionally male jobs roles such as wood machinist.

There was a good sense of community with days out, sports days, canteens and such like.

One perk for the local population was that the public were allowed to go in once a week to get offcuts for firewood that were brick sized laying in the yard.

In 1972 the company was sold to Montague Meyer. In November 1973 Basil Crosby, the popular and well-liked owner, was killed following an air crash in the USA alongside the MD/

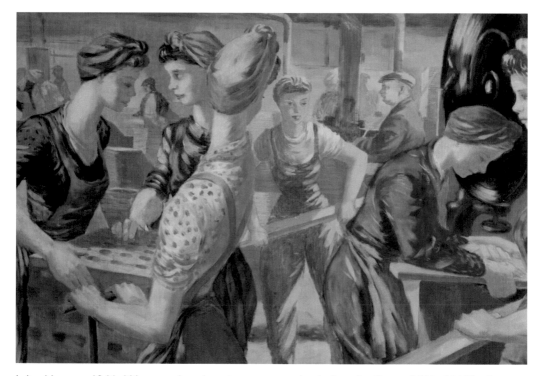

John Hutton, 1946. Women played an important role during the Second World War in manufacturing ammunitions. (Farnham Museum)

Above: These paintings were hung in the staff canteen at Crosby Doors. (Farnham Museum)

Below: Babbs Mead cottages opposite the site of Crosby. Residents would once have worked at the brewery that was located nearby.

The site of Crosbys Doors, now an office block.

company secretary Mike Pengilly whilst they were on a business trip. This resulted in the company changing hands several times before finally being incorporated into the Canadian group Premdor in 1994. Much of Farnham's Crosby Doors saw its equipment and machinery being moved to new locations in Barnsley and Swindon, and Crosby Doors closed its own doors in the early 1990s.

The Crosby Doors building was demolished in the 1990s and a new set of commercial buildings have been constructed. Today the roads around this area are called Crosby Way and Pengilly Road.

ART AND CRAFTS

Farnham has the privilege of being able to refer to itself as a Craft Town and England's first World Craft City. Crafts have been practised in the area since the Roman period – the district was known as a pottery centre due to its supply of gault clay, oak woodland for fuel and good communication links. Kilns dating as far back as AD 100 have been found in the area.

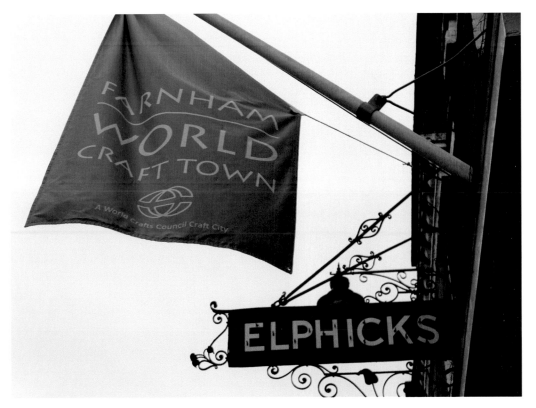

Farnham – a World Craft City.

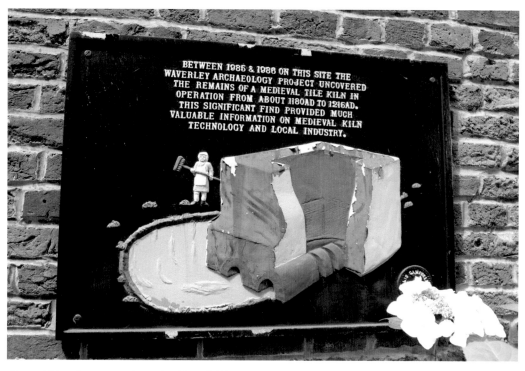

Above: Kiln information board at Borelli Yard.

Below: Alice Holt. Roman pottery kilns are situated on the Hampshire-Surrey border. They manufactured coarse, grey pottery from the first to fifth centuries.

UNIVERSITY FOR CREATIVE ARTS

The founding of Farnham Art School in 1866 cemented Farnham as a creative town. The school originally met in the Bailiff's Hall, Town Hall Buildings. In 1880 there were eighty-four students, of which forty-two were day students and forty-two evening. It then moved to 25 West Street in 1939, into premises recently vacated by Farnham Girls' Grammar School. It was a small school with only a few part-time members of staff teaching drawing, painting, sculpture, graphic design, and ceramics. However, its reputation was growing. At the end of 1968 the first moves to merge the two art schools at Farnham and Guildford were underway and the West Surrey College of Art and Design evolved between 1969 and 1970. It became University for Creative Arts in 2008.

Herbert Allen was appointed Master of the school in November 1889, later becoming Director until 1927. He encouraged the Arts and Craft movement in Farnham and he himself specialised in watercolour, chalk and pencil artwork and concentrated on landscapes, people and the country life of Farnham and surrounding areas. Towards the end of the 1800s, Allen commissioned one of his ex-students, Harold Falkner, to design a home for him in Farnham on the Tilford Road.

Harold Falkner was born in Farnham in 1876 and attended the local grammar school. He lived in Farnham all his life and became a notable architect but built nothing outside the area. As one of the founders of the Farnham Society in 1911, he was central in ensuring that new buildings in the town were in a proper style, usually neo-Georgian but sometimes neo-Tudor. He designed many himself, the most prominent being the Town Hall.

With his great friend and Farnham businessman Charles Borelli he wielded a large influence on construction and demolition within the town. In 1897 he designed the Victoria Memorial Baths, between 1900 and 1925 designed over twenty houses in Great Austins, but also pulled down Norman Shaw's Knight Bank and the Victorian Town Hall.

Farnham Art College.

Left: Farnham Art College.

Below: Memorial Baths.

Above: Harold Falkner's home in West Street. When he died in 1963 he left his house to The Farnham Society.

Right: A fine example of Arts and Crafts, built in 1909 by architect Richard Bassnett Preston as a church hall for St Andrew's Church.

POTTERY

The School of Art's involvement with the local Farnham pottery and the Arts and Craft movement came in the 1890s at the suggestion of Herbert Allen. Absalom Harris founded the pottery in 1872 at Wrecclesham, and around the 1880s started the production of Farnham Greenware. Greenware was first exhibited at the school of art on 2 December 1890. George Sturt noted in his journal that Absalom Harris, 'beaming as usual, ... had some nice pottery on show'.

Allen commissioned a number of 'pottery shapes' for his students to draw. Later he provided Absalom with new designs for pots from the late nineteenth century until 1943. These were mainly inspired by sixteenth-century Greenware in the Victoria and Albert Museum in London. Business boomed and large quantities of pots were supplied to Heal's, Liberty and others. The Queen Mother was a customer.

The pottery operated its own clay pits, a small railway to bring clay to the working area, had four working kilns and employed up to thirty men. The business went into a long decline after the Second World War, but the link with the Farnham School of Art continued, and student potters, including Terrance Conran and Lord David Queensbury, who trained at the art school, gained experience at the pottery. However, the pottery could not compete with larger manufacturers and the artware work lost its popularity. The main production was in horticultural items, with a few bespoke pieces. Five generations of the Harris family ran the pottery business until production finally ceased in 2000. Two-thirds of the site was sold off and the land developed for housing.

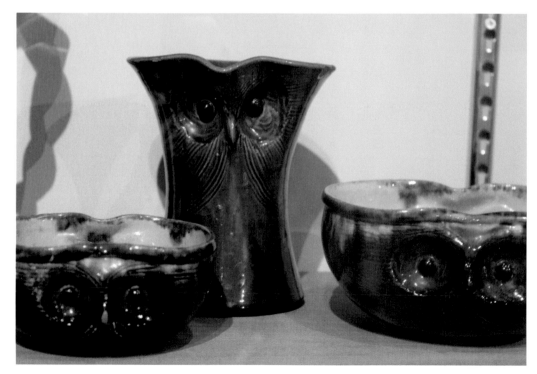

The Owl Pottery pieces are the most collected of Farnham Pottery wares.

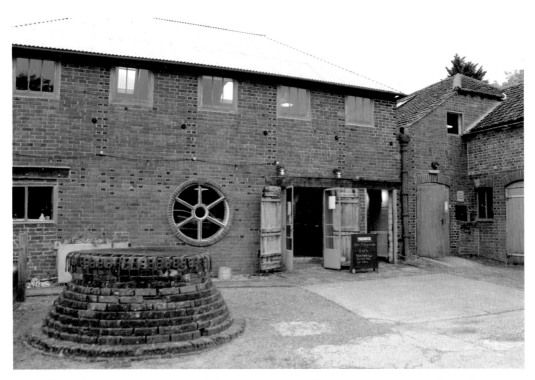

Above: Farnham Pottery, one of the best-preserved Victorian potteries in England.

Below: Farnham Pottery, a Grade II listed building.

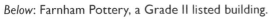

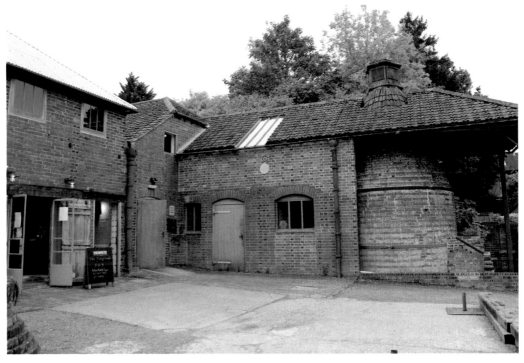

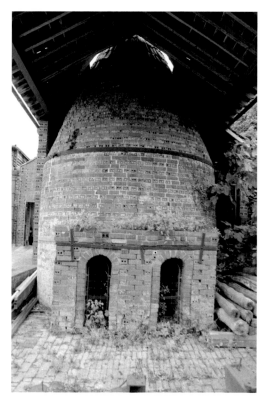

Farnham Pottery.

In 1998 the pottery was acquired by the Farnham Building Preservation Trust. The Farnham Pottery was statutorily listed at Grade II on 27 May 1999. Since then, a comprehensive programme of restoration has taken place. Today it is a lively pottery centre, combining both the production and teaching of pottery.

GALLERIES

Farnham and the surrounding villages is home to a staggering number of craft makers. Some of these crafts are for relaxation, some for small businesses and some internationally renowned. There are workspaces and studios, as well as independent shops and galleries.

One gallery is the Ashgate, opened at 19 South Street in 1960 by Elizabeth and Merton Naydler, with the support of Leszek Muszynski, a teacher at Farnham School of Art. The gallery moved into Waggon Yard in 1966 to new, larger premises. It supports emerging artists by exhibiting work and promoting the creative process for all communities through workshops, etc.

Next to the West Surrey College of Art and Design is The Crafts Study Centre. This was founded on 1 April 1970. The mission statement on that day stated that 'the object of the charity is the advancement of the education of the public in the artistic crafts'. It is a specialist university museum of modern craft.

Farnham Maltings is a successful arts and cultural centre. The Maltings date back to the mid-1700s. The buildings have been used as a tannery and during the 1800s as a brewery. It continued to be used as a brewery until the 1950s when brewing on the site became

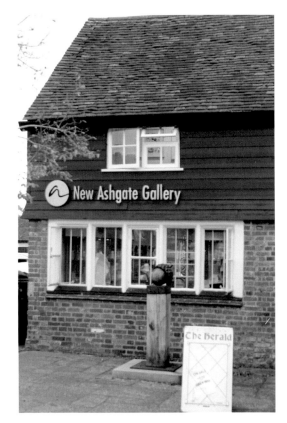

Right: Ashgate Gallery.

Below: Craft Study Art Centre.

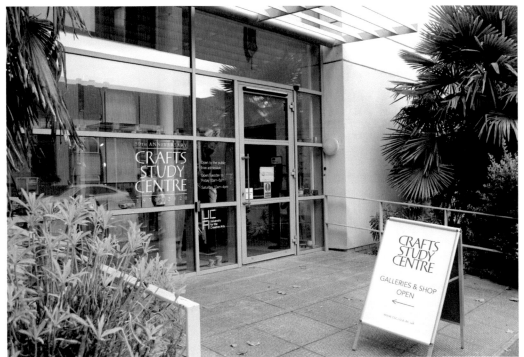

uneconomic and the building was abandoned and fell into disrepair. Later, the building was sold to the town of Farnham and a significant restoration process, assisted by local volunteers, saw the building come back into use during the 1970s. The first monthly Maltings market was held at this time and continues to this day. The building now includes artists' studios, galleries, cafes and dance studios. Maltings now looks after Farnham Museum. The museum was founded in 1961 to provide the Farnham community with a collection dedicated to the history of the local area.

In 2020, Farnham was awarded World Craft City status. Farnham is the first town in England and only the third region in Europe to be given this accolade. This award recognises that craft remains relevant to contemporary life in Farnham.

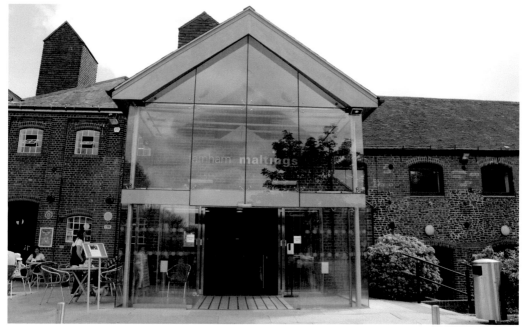

Above: Farnham Maltings main entrance.

Left: Billboard advertising events at Farnham Maltings.

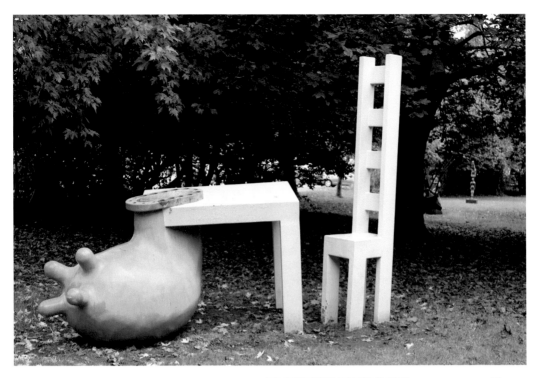

Above: Farnham has many art trails: Udder and Over (2002), Paul Cox. Sculpture at UCA.

Right: Farnham Craft sign.

THEATRE

Another form of art that Farnham is proud of is theatre. Professional theatre has been in Farnham for more than seven centuries, from the first performance for the Bishop of Winchester and the Royal Court at Farnham Castle. In 1939 travelling players were offered a sixteenth-century barn in Castle Street and established The Farnham Playhouse. The barn was said to be haunted by a disappointed lover, Jolly Jack Tar, who, having spent several years in the Navy sailing the seven seas, returned to Farnham to claim the hand of his beloved, only to find her married to another – he is thought to have hanged himself in the building.

This playhouse later became the Castle Theatre and by the late 1960s was so successful that a new larger theatre opened, the Redgrave Theatre, built in 1974. A modern, purpose-built theatre designed by architect Frank Rutter, the Redgrave Theatre replaced the Castle Theatre. The Redgrave Theatre was named after the actor Sir Michael Redgrave, who inaugurated the start of the theatre's construction in September 1971. Judi Dench was among the founding members. The theatre was officially opened on 29 May 1974 and commenced with a production of *Romeo and Juliet* attended by Princess Margaret.

In 1981, the Redgrave Theatre staged the first revival of Noël Coward's *Cavalcade* since 1931 in a production directed by the inspirational David Horlock (1942–90) with a cast of twelve professional actors and 300 amateur performers, myself included! The production seized Farnham in *Cavalcade* fever and was filmed by the BBC and shown in 1982 as a two-part documentary, *Cavalcade – A Backstage Story*.

The Redgrave Theatre sadly closed in 1998, but the demand for theatre is high and many people seek out local productions such as the Tilford Players.

Site of the Castle Theatre – in a converted barn.

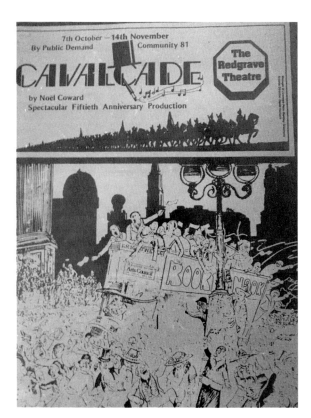

Right: Programme for
Cavalcade 1981.

Below: Local theatre has always
been popular. This is *The Waltz
of the Toreadors* by the Boundary
Players (formed in 1939). My
sister Colleen is in the maid
outfit standing at the head of the
bed. Performed 1980, Rowledge
Village Hall.

RETAIL

Farnham's status as a market town dates back to the Middle Ages where it held a weekly market. For centuries market stalls would have lined the bottom of Castle Street and The Borough. It was not until the 1860s that shops as we know them today came about. Due to more urbanisation, people no longer had the facilities to grow food themselves or keep livestock. It was then that market stalls became shops, with fixed prices to entice people in. It was the golden era of the high street (or West Street in Farnham's case).

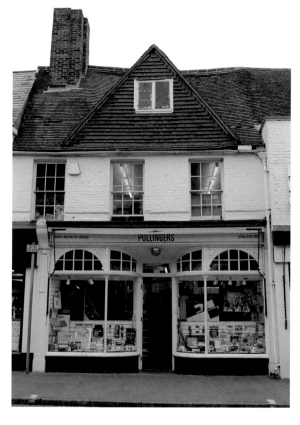

Pullingers Stationers is located in West Street. It is Farnham's oldest surviving business, established in 1850.

But it wasn't until the Edwardian era that shopping came of age, when product choice matched customer service. The Votes for Women movement also pushed for women to have somewhere respectable to go, such as tea shops and department stores.

Drapers' shops were an essential part of the Edwardian high street, selling cloth and fabrics by the yard. Many of the draper shops evolved into department stores, such as Farnham's Elphicks, offering a wide range of goods within different areas of the store.

Elphicks was founded by George Elphick. He moved to Farnham from Waltham Green and bought the drapers and outfitters business of Chilton and Scammell at 13 West Street in 1881. It still trades from the same location today and is a local institution. George Elphick ran a tight ship, and the customers were referred to as sir, madam or miss. Staff had to be well turned out at all times. According to the 1991 census, he lived at the property with his wife and daughter, plus several boarders who were employed at Elphicks. George was also a churchwarden and a staunch follower of the Conservative Club. He was a notable swimmer and a founder of the Bush Bowls Club. Over the years Elphicks has expanded and developed. The business continued to be owned by the Elphick family until October 2004, when Elphicks was acquired by Tudor Williams (Holdings) Ltd. (Incidentally, Augustus Toplady, writer of the hymn 'Rock of Ages', was born in a cottage on the Elphicks site in 1740).

Another successful business was the Borelli family's clockmaker's shop. It was based at 35/36 The Borough and they had a royal warrant to Queen Victoria.

Charles Borelli senior was born in 1844 in Lombardy, Italy. The Borellis were descendants of Giuseppe Borelli who was one of thirty children of Pasquale Domenico Borelli and his four wives. Charles came to England as a boy to live and work with an uncle in Farnham,

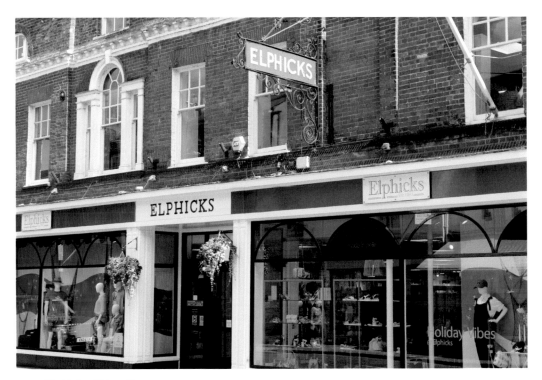

Elphicks, West Street.

Donato Borelli, who was a silversmith based in West Street. In due course he took the business over and it became a successful clockmaker's. When he died in 1917 the business was left to his son, Charles E. Borelli.

C. E. Borelli junior was born in 1873 at No. 48 Castle Street. With Harold Falkner he was responsible for the beautiful restoration of many buildings in Farnham during the early twentieth century. Their first project together was No. 40 The Borough. This structure was hidden behind a Victorian facade but with careful reuse of materials it was returned to something like its original seventeenth-century appearance. Together Borelli and Falkner formed the Old Farnham Society in 1911. Charles was also chairman of Farnham Urban District Council and was a councillor for many years. Borelli's had a keen interest in trees – which was very forward thinking as they act as cooling shade in these extremely hot summers that we now experience. Borelli was instrumental in the 1909 conversion of Gostrey Meadow, formerly a Victorian rubbish dump, into a public open space. In recognition of his life's work in the town there is Borelli Walk, Borelli Yard and Borelli Mews.

Borellis' – note the 'By Appointment to Her Majesty' fanlight above the door. The shop was closed in 1974.

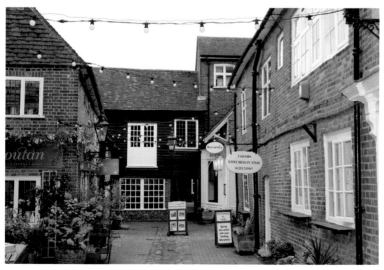

Borellis Yard.

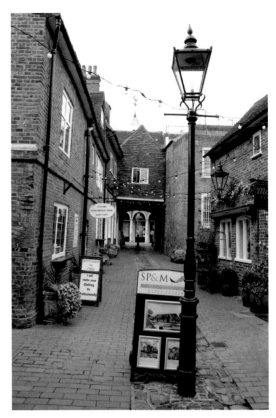

Right: Borellis Yard.

Below: Gostrey Meadows.

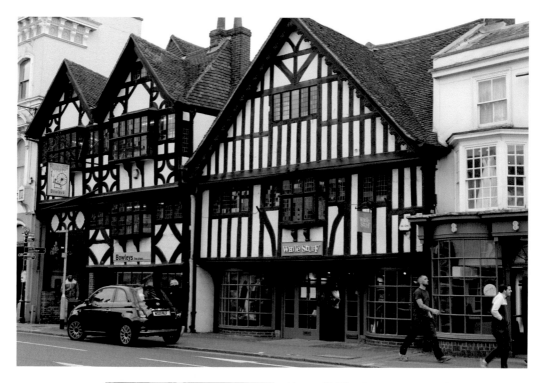

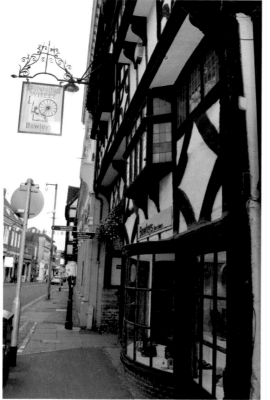

Above: 40 The Borough dates from the seventeenth century and has served as a post office, The Goat's Head Inn, The Spinning Wheel antiques shop, and a shoe shop.

Left: 40 The Borough.

WOOLMEAD

In the 1960s another golden era arrived for Britain's high streets.

Mass production and disposable culture took off, bringing prices down. Young people didn't want clothes made to last; they wanted fashionable clothes. And in 1964, the Resale Prices Act opened the way for buying in volume and slashing prices. What customers gained in choice and discounts they lost in personal service. This was the era of self-service.

In 1964 a controversial shopping spot was created in response to the change in shopping attitudes. This was known as the Woolmead. Approximately forty Tudor, Georgian and Victorian buildings were demolished and replaced by a flat-roofed brick and concrete structure. This development drew much criticism at the time from townspeople and architects, including Falkner.

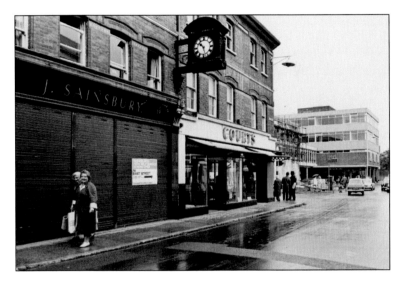

The Borough – the Sainsbury's store had closed for a new one in the Woolmead that is in the background. (© The Sainsbury Archive, Museum of London)

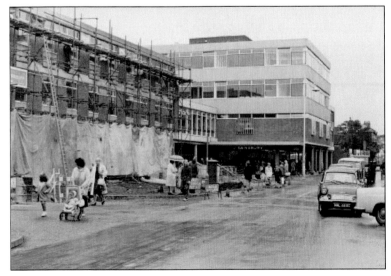

Woolmead, 1966. (© The Sainsbury Archive, Museum of London)

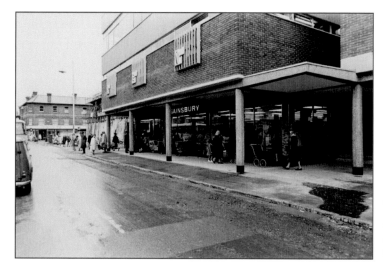

Woolmead, 1966.
(© The Sainsbury
Archive, Museum of
London)

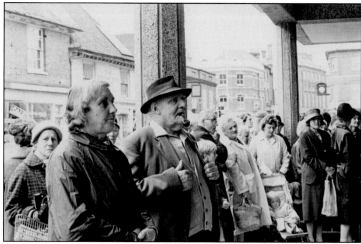

Waiting for
Sainsbury's to open,
Woolmead, 1966.
(© The Sainsbury
Archive, Museum of
London)

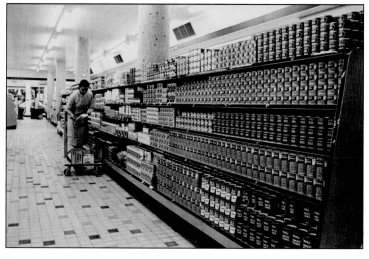

Stacking shelves
in Sainsbury's
Woolmead, 1966.
(© The Sainsbury
Archive, Museum of
London)

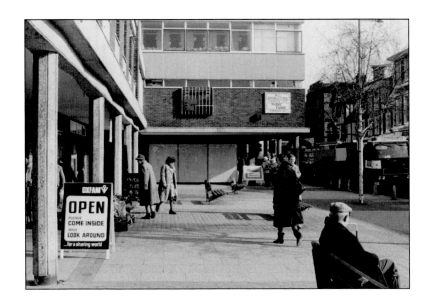

Woolmead, 1983. (© The Sainsbury Archive, Museum of London)

Many well-loved shops such as Roses Seeds Merchants and others were lost. One shop that survived the cull and retained its old-fashioned airs was Smyths (where I was a Saturday girl in the mid-1980s). Nestled next to Cambridge Place, at 10 East Street, it was established by James Smyth. He was born in 1873 in Down, Ireland, and came to Farnham with his siblings. By 1911 he was advertising his shop in Kelly's Directory. He married Rose and they went on to have several daughters and a son. By the time I started work at Smyths the three formidable daughters were now in charge. Uniform was black skirt and cardigan with a white shirt. We would be positioned at different points throughout the store in an old-fashioned *Are You Being Served?* type scenario. The sisters worked on the principle that idle hands are the devil's workshop – once I spent a good part of Saturday sorting old receipts into different piles with their dates, and once finished I was asked to put them in a bag and throw them out. Another task was washing outdoor windows whilst heavy snow fell (I was only allowed back in when a member of the public complained). Nevertheless, it was a quality shop selling school uniform, evening dresses and large hats.

Woolmead with Smyths next to Cambridge Place. (© The Sainsbury Archive, Museum of London)

Milestone in East Street. This area was once the site of a toll bar at the entrance to the town.

Opposite Smyths was The Gorge, a cafe with waterfalls and orange fibreglass stalagmite-like caves where you'd get a cola float or a milkshake. Today the Woolmead is currently undergoing redevelopment.

LION AND LAMB

Tucked off the busy West Street, via a historic listed Tudor archway, is the cobbled, car-free shopping precinct the Lion and Lamb. It's named after a hotel that used to occupy the West Street frontage. The courtyard was part of a sixteenth-century coaching inn. For many years the courtyard was home to a dilapidated warehouse and a printing works. Redevelopment began in the 1980s and today there is a successful buzz with luxury shops and cafes.

At the far end of the yard by the statue and large supermarket once stood William Kingham and Sons. This was a large retail and wholesale business that had two shops in West Street and a warehouse in the Lion and Lamb. It was established in 1852 by William Kingham who was born in Watford, Hertfordshire. For over a hundred years it was a favourite for Farnham shoppers, especially for the bacon that they cured at the back of their retail shop at 16 West Street, adjacent to Church Passage – which was given the nickname Streaky Bacon Lane.

Over the years there have been numerous shops come and go in Farnham town centre. In South Street was Miss Tigwell's Fancy Goods, which included toys and clay pipes; Rickards the children outfitters; and my personal favourite, Pocock's the bakery that sold Devonshire Buns with artificial cream and jam, which was a Friday treat after shopping day.

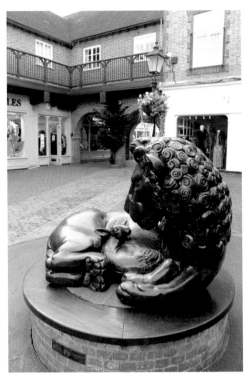

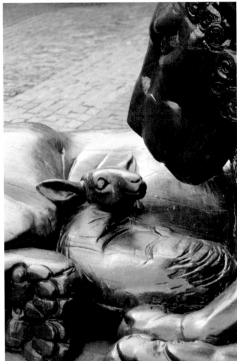

Above left: Lion and Lamb sculpture by Edwin Russell, 1986. It is carved from teak.

Above right: Lion and Lamb sculpture.

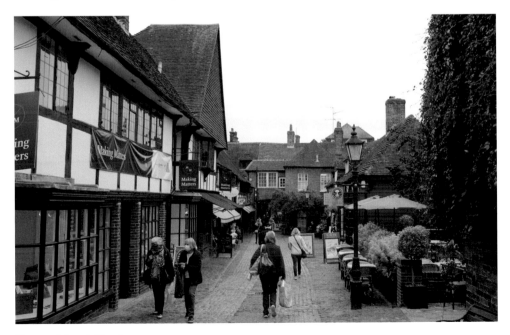

Lion and Lamb Yard.

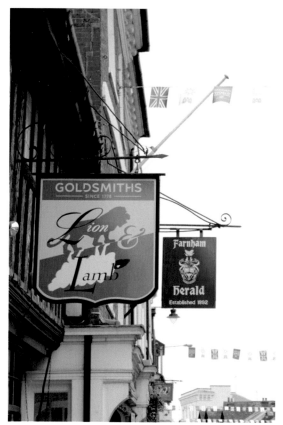

Left: Street signs at the entrance of the Lion and Lamb.

Below: Lion and Lamb Courtyard, Frith Series.

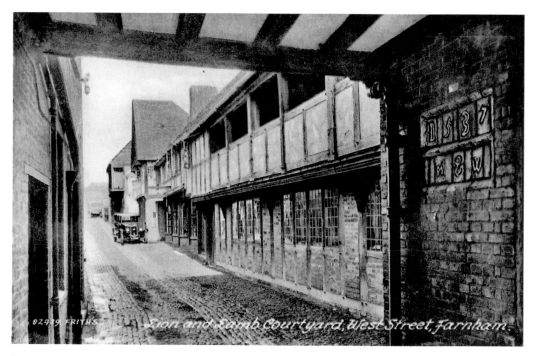

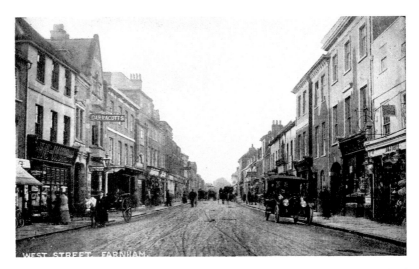

West Street,
Frith Series.

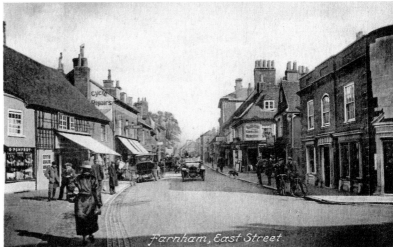

Farnham East
Street, Frith
Series.

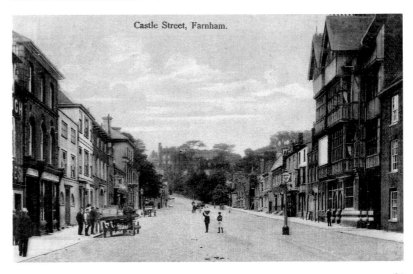

Castle Street,
Sturt Series.

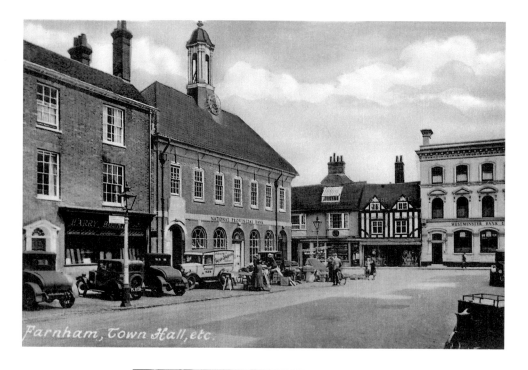

Above: Farnham Town Hall, Frith Series.

Left: Colleen outside Hales TV Repair Shop.

Unfortunately, I do not have the space here to mention all the shops that have come and gone but I will mention Hales Radio where my father, Kevin Taylor, worked in the late 1950s. G. A. Hale was an avid photographer who started trading in The Borough in the early twentieth century as an electrician. In the 1920s G. A. Hale recognised the potential for wireless concerts and he led the way in Farnham for organising this new type of entertainment. He would set up three loudspeakers in Gostrey Meadows and sell tickets to the public to hear shows and important announcements such as services from St Paul's. In 1937 Hales started to advertise TV sets despite there being no guaranteed reception. My father joined Hales in around 1955 after finishing school at St Polycarp's, then Heath End, where he started training as a television engineer. After leaving Hales, Kevin went to work at William Dibbens, later UBM, which was located at East Street.

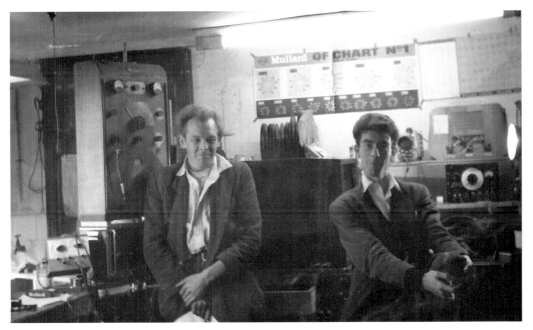

Hales. Kevin Taylor (on right) with colleague. (Courtesy of Hales)

THE FUTURE OF FARNHAM

Residents are proud to live in Farnham, and for good reason. The historic centre is designated as a Conservation Area for its architecture and historic character. The town is in a green and airy setting, and the nearby Surrey Hills are an Area of Outstanding Natural Beauty. Within the town there are green open spaces, such as Farnham Park and the Bishop's Meadow. The River Wey flows through the town contributing to Farnham's natural environments.

Since the construction of its eleventh-century castle, Farnham has continually adapted and evolved. Today, Farnham still continues to flourish. In the 2011 census (Office for National Statistics) the population had grown by 25,000 from the last century, bringing it to approximately 40,000. Of that number 20,140 residents were economically active with many of them working outside of Farnham, for example commuting. The ethos of the town is to retain a thriving local economy rather than becoming a dormitory town. Much of the local business is within the service industry. The town centre is the focus for Farnham's service sector. Offices are located within the older Georgian and Victorian premises as

Bishops Meadow.

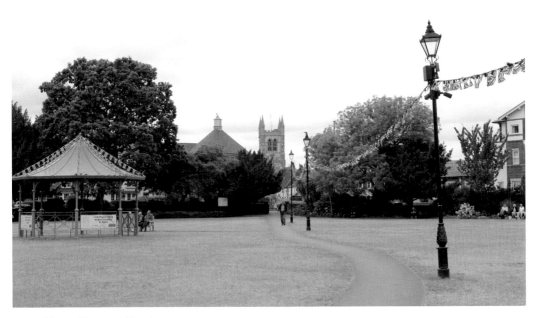

Above: Gostrey Meadows.

Below: River Wey meandering through fields.

well as modern office blocks including the Millennium Centre, Headway House, St Georges Yard, St Paul's House and St Stephen's House.

A 2022 national study (Vitality Ranking) of the retail health of shopping and leisure destinations across the country has ranked Farnham in eleventh place nationally – three places higher than in 2021. Changes to shopping habits because of the pandemic have led to more people working from home, resulting in an increase of people shopping locally. There is also a thriving evening economy with a popular pubs and restaurants scene. The number of restaurants and cafes within the town centre has increased over recent years.

Above: Millennium Centre, once meadows behind Crosby Doors.

Left: St Georges Yard, now office buildings. It has been suggested that the first ever two-minute silence was held here, started by J. Alfred Eggar, an estate agent in Castle Street.

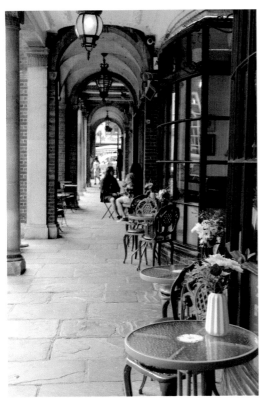

Above left: Time for a cuppa at Bailiffs Hall and Arcade.

Above right: Flower market at the bottom of Castle Street. There has been a market here since the Middle Ages.

There are two major redevelopments taking place in central Farnham. Firstly, there is the Woolmead, which is currently replacing the 1960s brutalist buildings with new retail units with residential units above, plus underground parking. Secondly there is Brightwell's, where Waverley Borough Council hopes to build 239 new homes, a cinema, shops, restaurants and town square. This is a multi-million pound scheme.

Tourism is also an important growing sector. The historic town centre and its cultural attractions bring in many visitors to the area. The local visitor economy is worth over £212,000,000 to Waverley's businesses and employs over 7 per cent of the workforce (Tourism South East, 2017). Tourism has bounced back since Covid-19 and is continuing to grow. Tourist accommodation is available within the town, which currently has three hotels, numerous pubs with accommodation and B&Bs. There is much for the tourist (and local) to do, according to Trip Advisor – the two main attractions are Birdworld and Alice Holt Woods. During the summer months, local musical groups fill Gostrey Meadow with sound and harmonies every Sunday, whilst Central Car Park plays host to the delicious Farmers' Market on the fourth Sunday of every month. October is Craft Month with lots of activities and workshops, and a new annual event is the Literary Festival that started in March 2020.

As Farnham evolves, other new industries will grow. One twenty-first-century development in Farnham is the film industry. Forestry England has been hosting filming events

Above: A common sight in Farnham at the moment – cranes dotted around Brightwells.

Below: Sports Centre with cranes in the background.

Above: More cranes.

Right: Flowers in Bloom, Downing Street.

Left: Farnham shop signs. Hanging signs have been refurbished along the town centre's streets and have become a feature of Farnham.

Below: Farnham has a successful pub scene.

Flowers in Bloom.

on its land at Bourne Wood for over twenty years. This popular woodland has been the backdrop to many internationally renowned films and television series, including *Gladiator*, *Harry Potter*, *War Horse*, *Thor*, *Wonder Woman* and *Transformers 3*, and more recently Netflix productions like *The Crown* and *The Witcher*. Forestry England has been successful in their planning application for the permanent change of use to continue using the site for filming purposes as well as forestry. This is the only Forestry England woodland in the country to have achieved this change of use.

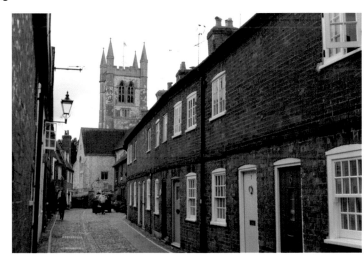

Lower Church Lane. Row of pretty cottages with St Andrew's in the background.

Above left: Farnham Bailiffs Hall and Arcade – a great spot for boutique shopping.

Above right: Borelli's Yard – another great spot for shopping.

Left: History is all around. Look out for ghost signs hinting at Farnham's past.

Above left: Victoria Gardens, created on the site of the former Victorian open-air swimming baths.

Above right: Jane Jones' bronze sculpture of a boy shivering, Victoria Gardens.

BOOKS

Aubery, John, *Perambulations of Surrey in 1673; The natural history and antiquities of county of Surrey*, eighteenth-century collection, online print edition

Bourne, George, *Memoirs of a Surrey Labourer*, Amberley Publishing, Gloucester, 2010

Cobbett, William, *Illustrated Rural Rides* (Christopher Morris), Webb & Bower Ltd, 1984

Culver, F. W., *The Ancient Venison Feast of Farnham*, Farnham, Surrey

Defoe, Daniel, *Tour through the whole of Great Britain*, Penguin Classics, 1978

Dunlap, William and Dorothy C. Barck, *Diary of William Dunlap, 1766-1839: The Memoirs of a Dramatist, Theatrical Manager, Painter, Critic, Novelist, and Historian*, New York: B. Blom, 1969

Elkins, B. H., *Wrecclesham and District – Memories and Odd Jottings*, Marketing Design Associates, Gloucester, 1993

Fitzgerald, Cathie, *Surrounded by Hops, The story of the Knight Family of Farnham*, Farnham and District Museum Society, 2014

Heather, Pat, *Women in Farnham and Its Villages*, Farnham and District Museum Society, 2015

Heather, Pat, *A History of Church Lanes, Downing Street and South of the River*, Farnham and District Museum Society, 2019

Marshall, William, *The Rural Economy of the Southern Counties Culture and Management of Hops*, G. Nicol et al, London, 1798

O'Rourke, V. D., *Hop Growing and its decline in the parish of Farnham*, Farnham and District Museum, 1973

Paris, Harry, *Lookback at Andover*, Andover History and Archaeology Society, 1966

Parratt, Jean, *Bygone Farnham*, Phillimore & Co. Ltd, 1985

Parratt, Jean, *Farnham by the Wey*, Chalford Publishing Company, 1995

Smith, Ewbank, *Victorian Farnham*, Phillimore & Co. Ltd, 1971

Smith, Ewbank, *Farnham in War and Peace*, Phillimore and Co. Ltd, 1971

Stevens, Florence, *To the Vicarage Born*, Farnham Museum

Sturt, George, *A Small Boy in the Sixties*, Caliban Books, 1982

Sturt, George, *Change in the Village*, Cambridge University Press, 1912

ONLINE SOURCES

http://www.arthurlloyd.co.uk/

https://www.cambridge.org/core/journals/historical-journal/article/rural-workers-and-the-role-of-the-rural-in-eighteenthcentury-english-food- Griffin, Carl Rural Workers

https://www.crondallsociety.co.uk/Chronicle/Entries/2017/5/4_Spring_2017_files/51936_crondall%20Spring%202017%20SPREADS_mpc.pdf

https://www.exploringsurreyspast.org.uk/themes/places/surrey/waverley/farnham/farnham_15002004/

https://www.farnham.gov.uk/discover/history-and-heritage

https://www.farnhamtrust.org.uk/

https://www.nationaltransporttrust.org.uk/

http://oastandhopkilnhistory.com/

http://www.starzina.com/

http://weyriver.co.uk/theriver/weyarun.htm

https://wreccleshamhistory.wordpress.com/

https://www.workhouses.org.uk/ Workhouses.org

ACKNOWLEDGEMENTS

I'm extremely grateful for all the support I have received whilst researching *Farnham at Work*. It has been a thoroughly enjoyable process researching the town where I was born and grew up. It has been a great excuse for perusing the streets of Farnham and taking advantage of all the wonderful coffee shops whilst resting my feet reading research material. I would like to thank Farnham Museum for allowing me to use images from their displays and their receptiveness when I have visited – it is much appreciated.

A big thank you to my mother, Margaret, who has shared memories of Farnham and has pointed out different areas of interest whilst accompanying me with my wanders around the town – I've enjoyed the company. I would also like to thank Russ, who once again has patiently checked my spelling and made sure that I've dotted the I's and crossed the t's. Any complaints on grammar please contact Russ! Astrid and Jarvis – thank you as always.

Farnham is a small town but has a wealth of history. Due to lack of writing space, I am unable to go into depth as much as I would like or cover all the topics I would have wished to include, but hopefully *Farnham at Work* is a good introduction to the history of this wonderful town. I hope you enjoy it.